IMAGES
of America

MELBOURNE
BEACH
AND INDIALANTIC

D1073052

Brevard County was originally named Mosquito County, and not without good reason. The ubiquitous mosquito inspired this bit of anonymous poetry:

> O Winged monster, terror of the night,
> Your constant buzz, and aggravating bite
> Make sleep impossible, and comfort slight!

(Drawing by Cathie Katz.)

IMAGES
of America

MELBOURNE BEACH
AND INDIALANTIC

Frank J. Thomas

ARCADIA

First printed 1999.
Reprinted 2000, 2001, 2003.

Published by Arcadia Publishing,
an imprint of Tempus Publishing, Inc.
2 Cumberland Street
Charleston, SC 29401

Printed in Great Britain.

Library of Congress Catalog Card Number: 99-61642

For all general information contact Arcadia Publishing at:
Telephone 843-853-2070
Fax 843-853-0044
E-Mail sales@arcadiapublishing.com

For customer service and orders:
Toll-Free 1-888-313-2665

Visit us on the internet at http://www.arcadiapublishing.com

To Annie Hellen

(Drawing by Eugenie Amalfitano.)

CONTENTS

ACKNOWLEDGMENTS

I would like to thank the following for their help in making this book possible: Tebeau Library of Florida History, Brevard County Historical Commission, Floridana Beach Homeowners Association, Barbara Smith Arthur, Robert Terry, Walter Obermayr, Eleanor Dillon, Steve Seiler, John A. Beaujean, Ada Parrish, Julian Leek, Phil Eschbach, Joe Wickham, Nalley Telemachos, Jim Culberson, Eugenie Amalfitano, Cathie Katz, Richard Wallace, Curtis Byrd, Douglas T. Peck, Renee Galeski, Nancy Spencer, Sarah Smith, Weona Cleveland, and the brains of the family, my wife Annie Hellen.

INTRODUCTION

Southward along the east coast of Florida stretches a series of long, low palmetto-covered islands, which stop the Atlantic and beat back the thundering surf. About midway on this coast, below Cape Canaveral, between the Indialantic bridge in the north and for 18 miles southward to Sebastian Inlet lies the community of Melbourne Beach. This is the story of that community.

For thousands of years before the coming of the white man, even before the coming of the Native American, this land rested in splendid isolation. Westward across the island grew sea oats, purslane, cord grass, and ink berry, which then gave way to palmetto, Spanish bayonet, yaupon, and nickerbean, festooned with entwined morning glory vine. Near the brackish Indian River, myrtle oak, cabbage palm, marsh elder, and mangrove grew thick and fierce.

Centuries passed without change in the timeless land. The seasons came and went, as now; days fell upon nights with a rhythm as regular and steady as the never-ending tides. Creatures continuously struggled for survival—raccoons, opossums, bears, deer, wild cats, snakes, rats, quail, and turkeys. And on the banks of the Indian River, alligators bellowed and hunted the night through while the calmness of the river was broken by the splash of leaping mullet.

The most historically significant event to take place in our community was the landing of Juan Ponce de Leon, on April 2, 1513. Historians are in nearly unanimous agreement that this landing took place within several miles north or south of the newly designated Ponce de Leon Landing Park. The 38-year-old governor of Puerto Rico commanded three ships on what turned out to be a seven-month voyage. During his three-day stay he searched for water, firewood, and, of course, gold. He made no contact with the native Ais Indians, who would still have been wintering on the mainland.

Another mention of the Melbourne Beach area is in *The Derrotoro of Alvaro Mexia* written by a young Spanish soldier, Alvaro Mexia, who, in the year 1605, explored south of the Indian River or the "the Great Bay of Ais," as he called it. His task was to map the region for Spain. On the eastern shore of the river, where Melbourne Beach now exists, he only noted that the shore was lined with mangrove swamps "as usual." He made no contact with the native people.

But some 4,000 years ago a primitive, nonagricultural tribe, the Ais, began inhabiting this area of the Indian River. They were small of stature and went about virtually naked. The men were known to paint themselves red and black for ceremonial occasions. In later centuries, they were known to live in crude structures covered with palmetto fronds. A stable food source was fish, which they speared from dugouts. Oysters and clams were also gathered from the river, and

archaeological evidence suggests that the Ais ate birds, deer, and even alligators. Their principal vegetable foods were palm berries, coco plums, and sea grapes. These would be gathered and stored against the cold months when the Ais would not venture far from their settlements.

The Ais practiced a form of nature religion. A Quaker merchant, Jonathan Dickinson, was shipwrecked in this area in 1696 and was held captive by the Ais for a time. He reported that with the coming of the first quarter of the moon the Ais would hold great ceremonies that would last all night with firelight illuminating their painted, sweating bodies. They danced about to the accompaniment of "rattles, shouts, expostulations, howling" until they collapsed in exhaustion and were revived in the chief's shelter with an alcoholic drink made of palm berries called cassena, or "the black drink." Although they held their chief, "Casseekey," in great esteem (his transportation consisted of two dugout canoes lashed together, whereon he would sit cross-legged on a raised platform while others would pole him down river) such respect did not extend to the aged, declining members of the tribe. As Dickinson noted "the younger is served before the elder, and elder people both men and women are slaves to the younger."

What caused the eventual disappearance of the Ais? Unquestionably, contact with the white man beginning in about 1700 had much to do with their decline and eventual departure from the scene. Around this same year, slave raids began from the Carolinas, missions were established in this area, and the cumulative effect of contact with white man, his diseases, and his rum appear to have thinned the Ais' ranks. By the year 1760 there were none left in this region.

Today, the only remaining evidence of this enigmatic tribe can be found in the shell middens excavated by local archaeologists. Here, the original inhabitants would discard shells, bones, and sometimes even bury their dead. Clam and oyster shells made up the most enduring material for early road paving material in the area, making up such shell roads as A1A and River Road. A large shell mound just north of Sunset Boulevard was used to pave the original tennis court at the present site of the Volunteer Fire Department on Ocean Avenue.

Except for the military making their way southward down the Indian River lagoon during the Seminole Indian wars the first half of the 19th century, or the occasional bedraggled survivor of a stormy Atlantic shipwreck washing up on our forlorn shore, Melbourne Beach remained free of human footprints.

After Florida became a state in 1845, our island became part of a county aptly named in honor of its chief residents: Mosquito County. Soon, however, we became part of Brevard County, and after the Civil War we began attracting attention from that war's Union veterans, several of whom had been stationed in Jacksonville, 175 miles north. Among these veterans who ventured onto our island late in the 19th century were Cyrus E. Graves, Alfred Wilcox, Rufus W. Beaujean, and Charles Latham. This was all government land, the price an affordable $1.25 an acre. During these years Congress was generous to its veterans' lobby, the Grand Army of the Republic (G.A.R.), and with ample bonus money these yankees began investing in island real estate. The first recorded sales were to Charles Latham in 1881, and Cyrus Graves in 1883.

In the same decade two brothers from Georgia, Robert and Charlie Smith, homesteaded Mullett Creek. Their direct descendants still live there. Pineapples were the first cash crop on the island, as well as certain vegetable crops.

The Lathams, Charles and "Ma," built Oak Lodge a few hundred yards above the Smiths at Mullet Creek. Oak Lodge attracted a steady stream of visitors, including famed ornithologist Frank Chapman. Several houses and the community chapel were built, and the settlement became a modest success. In 1923 the handful of residents along Ocean Avenue incorporated as a municipality, while the new toll bridge spanning the river brought the first automobiles.

We grew modestly until post-World War prosperity, and a Cape Canaveral Space Boom economy brought enormous changes in population and construction. One can still find a quiet, tranquil Florida in parts of our community, but it is becoming more and more difficult with each succeeding year.

One
THE BARRIER ISLAND

The barrier island is a sandbar that rose from the ocean floor during the muck and mists of long-ago millennia. Its geologic purpose is to protect the mainland from havoc wrought by Atlantic Ocean storms. The stretch of sandbar containing Melbourne Beach is 18 miles long, from the Indialantic bridge to Sebastian Inlet. It varies in width from 1 mile to 200 yards. From the ocean dune, the land gradually slopes to the Indian River lagoon. Rolling, regular depressions called savannahs formed by ocean waves ages ago once characterized this virgin land. Mangroves grew thick and uncontrolled along the western shore.

The first handful of settlers in the 1880s grew crops, while the mangroves grew mosquitoes. Only during and after the second world war, when low-flying airplanes from Melbourne Naval Air Station sprayed the newly invented chemical DDT over our island, was the mosquito plague diminished.

Road building did not come until 1921, when Ernest Kouwen-Hoven's 16-foot-wide, wooden toll bridge spanned the northernmost boundary of our community. Only by gradual increments did state road 140, which became our present-day A1A, extend southward down the island. It did not extend as an asphalt road to Sebastian Inlet until the early 1950s. Until 1965, with the coming of the present Inlet bridge, the road was a dead end.

Roads and streets were shell. They glistened in the sunlight. The road material came from ancient shell mounds composed of the cast off outer body of mollusks that generations of Ais Indians had left on the river shore. No thought was given to archeological significance; only their use as road-building material was considered.

The motorist did not dare venture his automobile off the pavement (such as it was). Getting stuck in the sand was a dreaded inconvenience notable until recent years.

Gradually, and then faster with the opening of the Sebastian Inlet bridge, our population grew. Communities within the Melbourne Beach community came into being: Floridana Beach, Melbourne Shores, Crystal Lakes, Sunnyland Beach, Aquarina, and Sebastian Pines.

Real estate lady Eleanor Dillon says that roads were so few until a few years ago she had to sell property by canoe. It is becoming harder and harder to imagine a time like that.

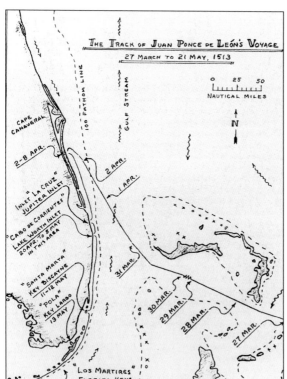

Historian and navigator Douglas T. Peck's recreation of Ponce de Leon's 1513 voyage resulted in pinpointing the Spanish explorer's landing site at Melbourne Beach. Historians of early Spanish history of the new world are impressed with Peck's findings.

When Ponce de Leon and members of his crew came ashore on Melbourne Beach on April 2, 1513, they became the first Europeans to set foot on the North American continent. The two days ashore were taken up in the mundane tasks of finding firewood and fresh water and in the fruitless search for gold.

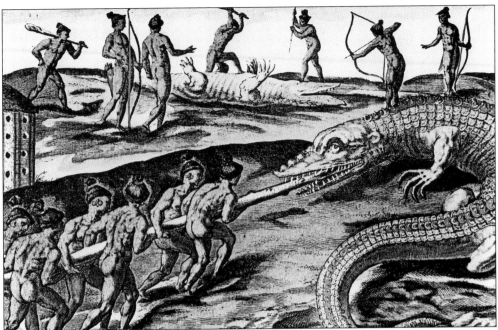

These two depictions of Native Americans created by French artist Jacques Le Mogne are of inhabitants in the north of Florida; however, the local Ais Indians could not have differed greatly from them. Taunting the alligator so as to cause its open-mouthed charge would seem to indicate bravery and courage, or perhaps foolhardiness.

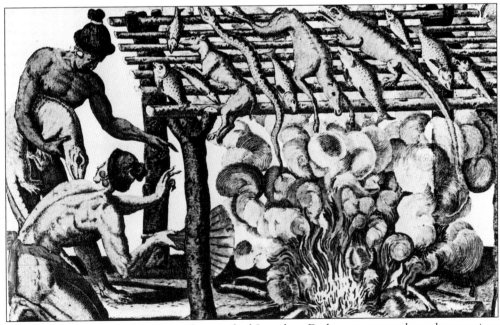

The Ais would eat anything. The shipwrecked Jonathan Dickinson reports how these natives would only scale their fish before half baking them for consumption, guts and all.

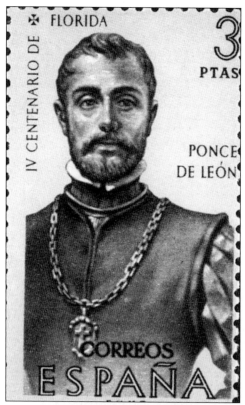

Ponce de Leon's discovery and landing on Florida's shores occurred on April 2, 1513, and it was long thought that this event took place at or near St. Augustine. This conclusion was based upon studies of Ponce de Leon's compass headings, though these studies did not take into account either magnetic deviations inherent in 16th-century compasses or the effects of the Gulf Stream and prevalent winds on his course. It was not until a professional navigator with 50 years of experience, Douglas Peck, carefully re-traced Ponce de Leon's route in a sailboat and took into account all the elements not previously considered that a more accurate picture of the landing site came to be known. In his book *Ponce de Leon and the Discovery of Florida*, Peck details the method and procedures he used to re-sail Ponce's route. His evidence is so compelling and his work so carefully done that many prominent historians have concluded that Melbourne Beach was indeed the site where Ponce de Leon first came ashore to claim the land for Spain centuries ago. (Courtesy of Tebeau Library of Florida History.)

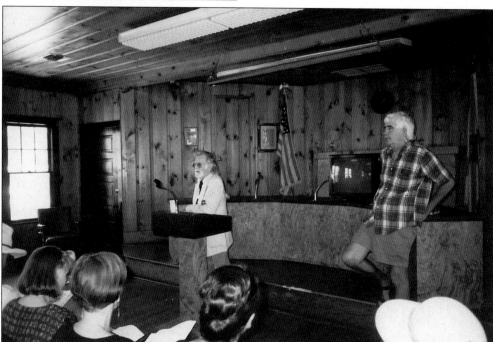

Navigator and historian Douglas F. Peck makes his case to a full house in the Melbourne Beach Community Center on May 4, 1996.

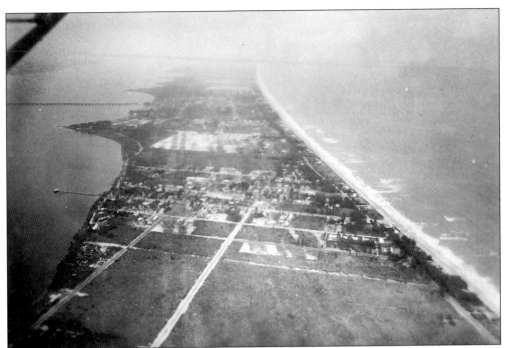

The barrier island stretches some 18 miles, from the Indialantic causeway to Sebastian Inlet. This 1940s view is of the northernmost section, the bridge across the Indian River Lagoon.

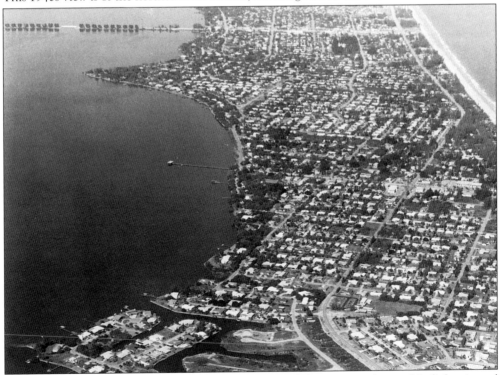

This is a later 1980s view of the northernmost part of the municipalities of Indialantic and Melbourne Beach. (Photo by Julian Leek.)

13

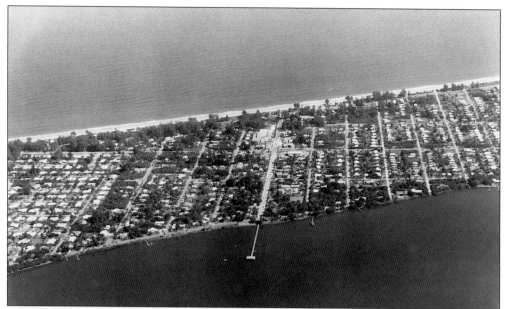

The island varies in width from just 200 yards to 1 mile. Here, the view across the island is seven-tenths of a mile. (Photo by Julian Leek.)

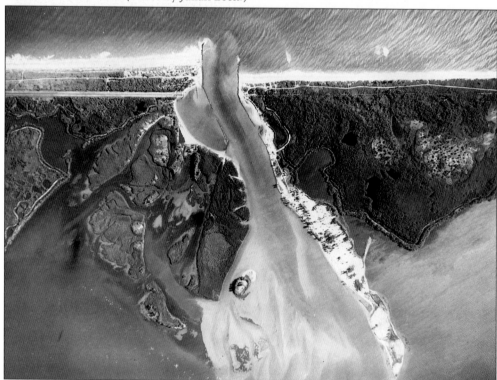

At the southern end of Melbourne Beach is Sebastian Inlet. At least six inlets have been known to cut through the barrier island to the Indian River Lagoon. These inlets, at the mercy of ocean storms, have changed locations and been plugged up with sand over the centuries. (Photo by Sterling Hawks.)

Finally, in 1919, the creation of the Sebastian Inlet Tax district promised residents that "bringing in fresh ocean water twice a day will purify the Indian and Banana River Lagoons and make the river water ocean blue. The warm ocean water coming through the inlet will save vegetable and citrus crops during cold snaps. An inlet will bring back fish and oysters, largely increasing the commercial fishing industry, thus reducing the high cost of living." (Photo by Rodney Kroegel; courtesy of Brevard County Historical Commission.)

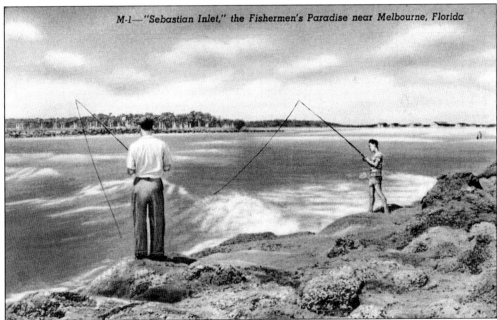

M-1—"Sebastian Inlet," the Fishermen's Paradise near Melbourne, Florida

Sebastian Inlet has been continuously open since 1948, but before that date, the violence of the ocean had opened and closed it many times. "Gibson's Cut" in 1895 was the first of many futile attempts to open the inlet with hand labor.

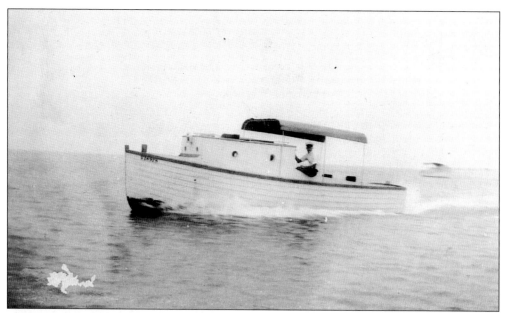

During the Prohibition era of the 1920s, many boats such as Honest John Smith's *Pocahontas* allegedly made runs through the inlet to pick up contraband liquor from larger off-shore vessels or from Grand Bahama Island itself. Legend has it that the nickname "the real McCoy" came from a rum runner who "imported" only the best British liquor.

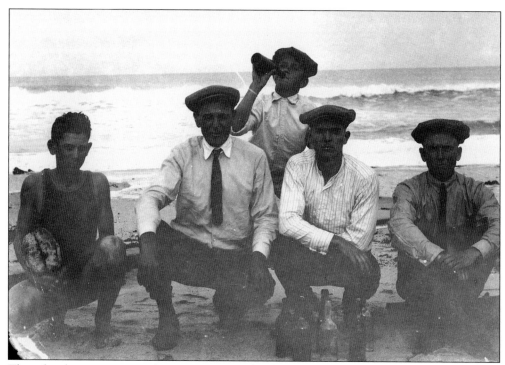

These local gents appear to be enjoying "sampling" a few bottles of Honest John's or the "the real McCoy's" hooch. (Courtesy of Brevard County Historical Commission.)

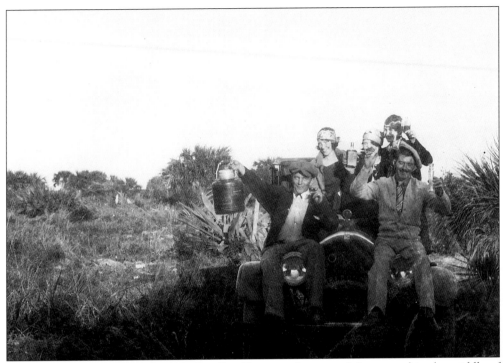

Hollis Bottomley and friends, including Dot Bruce in the upper left, stopped in the middle of what became highway A1A to pose with their containers of hooch, or bootleg liquor. The road to the inlet was one sandy lane wide. (Courtesy of Hollis Bottomley Collection.)

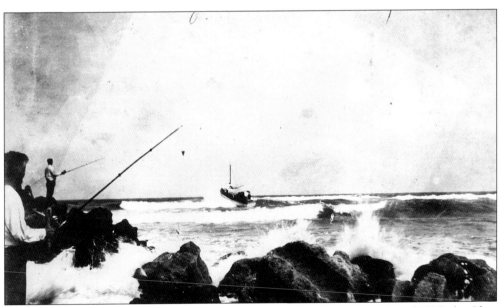

It wasn't long before tragedy struck the roiling waters of the inlet. In October of 1925, the *Clara A.*, carrying 23 passengers most of whom were tourists from the Midwest, flipped over in a wave shortly after this picture was snapped. Fourteen passengers were drowned.

A plugged up Sebastian Inlet is pictured here in the 1910s. The few visitors reported finding wonderful seashells.

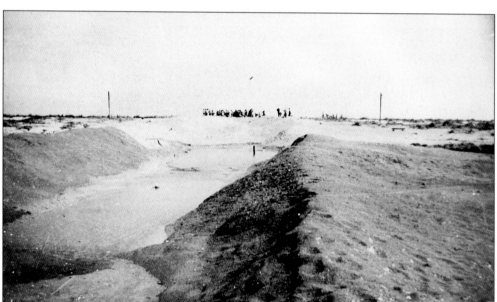

By the late 1930s, Mother Nature had again filled Sebastian Inlet. This photo shows the unsuccessful attempt in 1945 by the Navy's Underwater Demolition Team (U.D.T. "Frogmen") in Ft. Pierce to blast it open. It was said that the tops of palm trees for 2 miles around were blown off. (Courtesy of Sea Bird Publishing, Inc.)

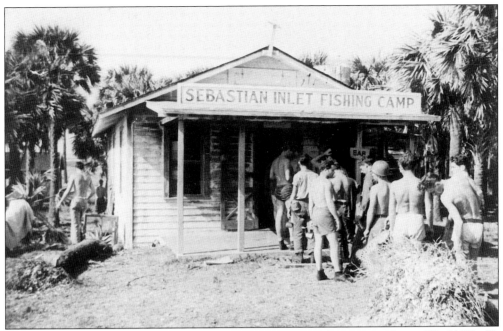

The military took over the inlet, including Don Beaujean's fishing camp, during World War II. Here the U.D.T. (Frogmen) are waiting for lunch. These elite Navy men suffered over 50 percent casualties during the Normandy invasion in June of 1944. (Courtesy of Sea Bird Publishing, Inc.)

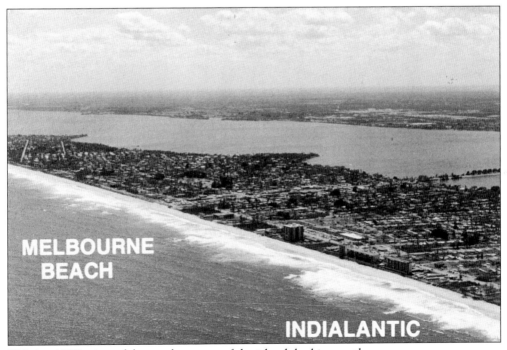

This is a 1980s view of the northern part of the island, looking south.

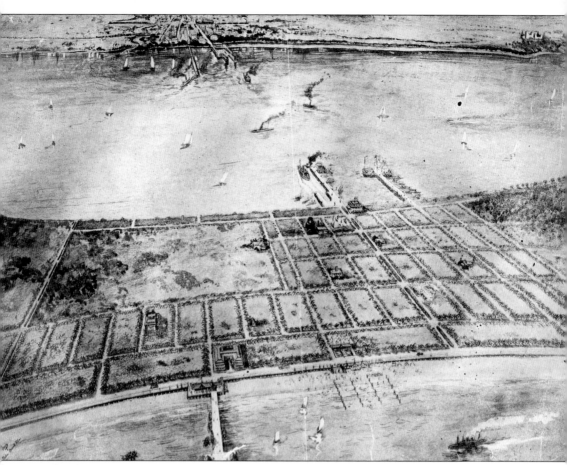

This fanciful and optimistic rendering was composed in 1919 as the toll bridge was under construction. The bridge was expected to bring a flood of investors and tourists to the barrier island.

Two

THE RIVER

The Indian River is a brackish, saltwater lagoon formed millenniums ago. It had always been clear, although during the rainy season amber waters would flow from the land, tinted by tannins from mangroves, buttonwoods, pines, and oaks. The calm waters of the lagoon were protected from surf and storm by the barrier island. The river's eastern bank was lined with mangroves, mosquito breeders par excellence. Even the hardy and highly adaptable Ais Indians abandoned the island during the warmest months. That is probably why Ponce de Leon did not stumble upon them during his 1513 landing. A later explorer, Alvaro Mexia, found the island's eastern shore boring. During his 1605 journey he speaks of the shore being lined with mangrove "as usual."

What was not so usual, however, was the less-than-awed attitude of the native Ais. The few Europeans who dared venture into this territory described the Ais as "brutal, warlike, sanguinary, furious, hostile, belligerent, tricky, and cowardly" and "foaming at the mouth." Missionaries from St. Augustine, both Jesuits and Franciscans, came upon the Ais at their own peril. Their murders very decidedly dampened enthusiasm in the religious community for the evangelical effort. This did not, however, prevent later corrupt St. Augustine governors from trading that colony's scarce iron goods and other merchandise for rare and valuable ambergris, a substance from the sperm whale, which the Ais collected in their ocean-going canoes.

Some 4,300 species of plants and animals make the Indian River one of the most diverse estuaries in the world. The first settlers on the Indian River found an incredible amount and variety of life.

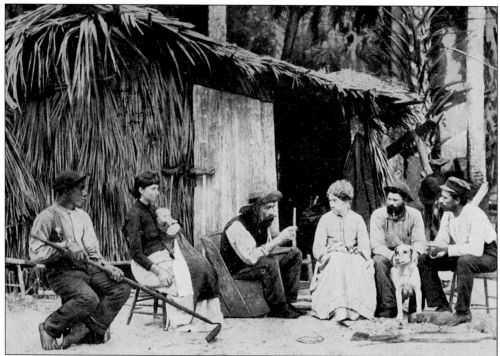

This 1880s postcard presents a none too complimentary view of the first settlers along the Indian River. Note the palmetto shack living quarters with no window, no screens, and no chemicals to keep the mosquitoes away. (Courtesy of Brevard County Historical Commission.)

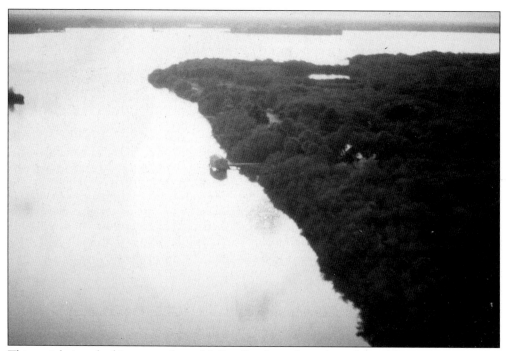

This aerial view, looking west, shows Mullet Creek on the right embraced by mangroves.

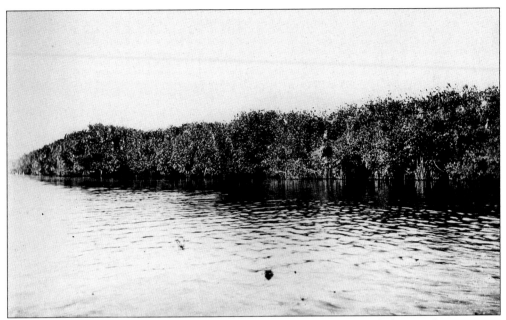

Mangroves provide shelter and food for a wildlife community that includes conchs, raccoons, lizards, oysters, crabs, and birds. The trees provide stability; they are a nursery for hundreds of Indian River Lagoon animals. (Courtesy of Brevard County Historical Commission.)

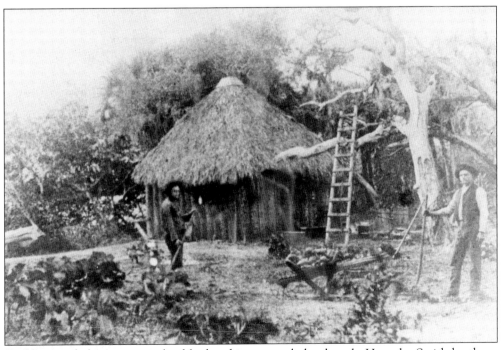

Grubbing and clearing virgin land by hand is extremely hard work. Here the Smith brothers, Robert and Charlie, pose for this expensive 1889 photograph at Mullet Creek in order to prove homestead rights.

Growth along the river, just beyond the mangroves, was generally lush and tangled. Land travelers were lucky to find a trail.

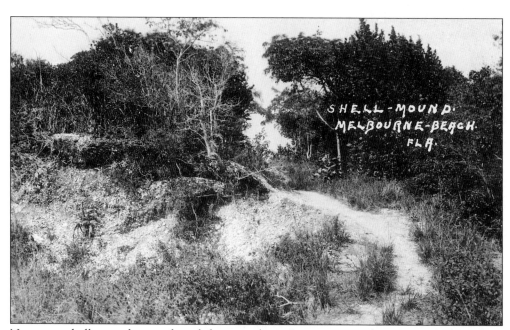

Numerous shell mounds once dotted the river shore. In most cases, these were simply garbage heaps where the remains of clams, oysters, conch, crab, fish, and other animals were dumped. Sometimes the mounds were used for human burials. This particular mound was 50 feet across, 13 feet thick, and 1,000 feet long.

Fishing was a calmer and less savage pursuit than hunting. Here, on February 26, 1948, John and Barbara Smith show off trout caught at Mullet Creek. The largest weighs 13 pounds and 4 ounces.

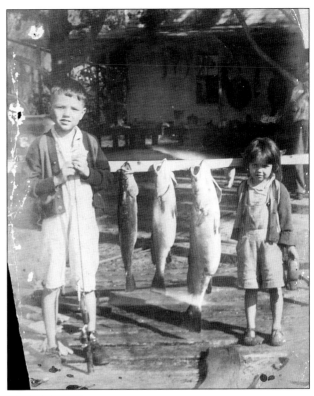

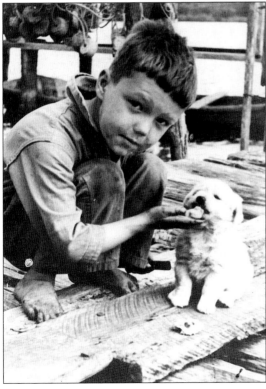

Little Johnny Smith is feeding an oyster to his dog, Snowball. Note the drying racks in the background.

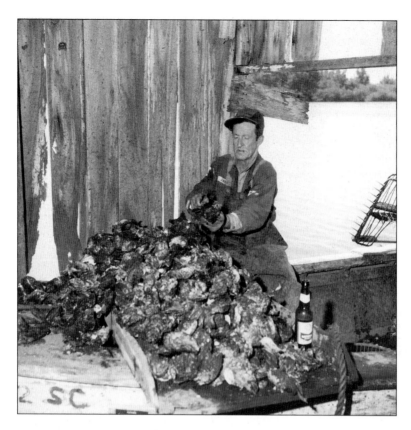

The Indian River was at one time bountiful in its supply of oysters and clams. Here, Si Jenkins is culling a good supply of oysters.

The most efficient fishing was done by gill netters, and all had drying racks, as shown here. The child on the right of this photo is Barbara Smith. Gill nets were recently outlawed in Florida.

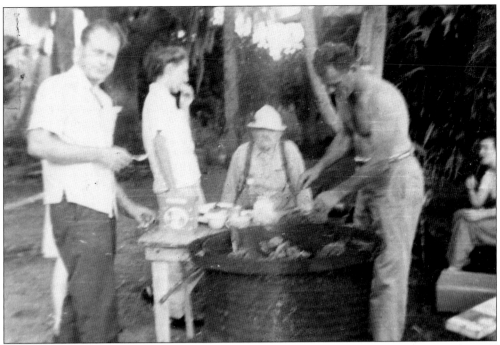

R.T. Smith, center, presides over an oyster roast. The raw oysters are placed atop the grill fashioned from a 55-gallon drum.

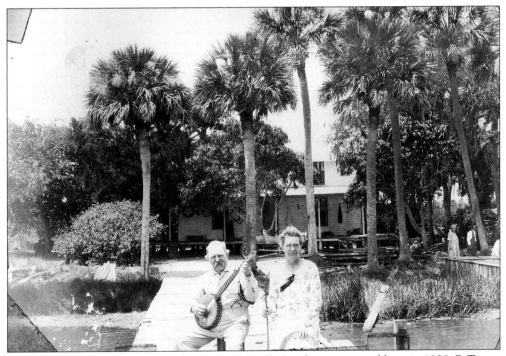

Robert Toombs Smith and his wife, Elizabeth Wells Smith, are pictured here in 1938. R.T. was known up and down the Indian River as a talented musician.

R.R. Ormond lived across the river in Grant, but he commuted regularly by boat for 26 years to grow crops at "Snaggy Harbor." Ormond harvested bell peppers and green beans, but the best market he found was in flowers such as amaryllis and Easter lilies.

Truck Farming

All along the Indian River, settlers took advantage of the offer by the federal government of land at $1.25 an acre. The coming of Flagler's railroad down the mainland provided much quicker access to northern markets than steamboats had previously provided. Many farmers, including the Smiths, became truck farmers, and on their riverfront acres they raised sweet potatoes, potatoes, collards, cabbage, tomatoes, string beans, corn, field peas, Indian pumpkins, and sugar cane. . . especially beans. R.T. Smith had an "In Beans I Trust" heading on his stationery. Fascination with these earliest Indian River farmers can be found in the title of a boy's Tom Swift-type book, *Boy Truckers on the Indian River*.

There was nothing glamorous in the lives of these farmers and farm workers. It was arduous, backbreaking physical labor. One had to constantly put up with clouds of mosquitoes, chiggers, fleas, sand flies, and no-see-ums. The earliest palmetto shacks had no screening; one had to sleep under a mosquito bar. Then one had to be constantly on the lookout for wild hogs, raccoons, opossums, and other wildlife that could ruin weeks of hard work in minutes.

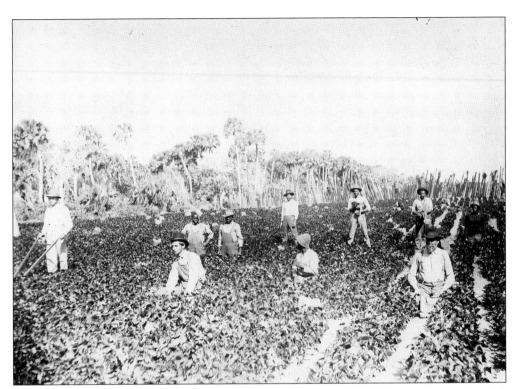

It is doubtful many truck farms had the number of workers shown in this 1900 posed photo of a bean farm. (Courtesy of Brevard County Historical Commission.)

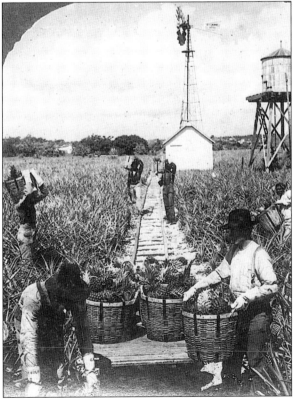

Most of what has been said concerning the need for physical strength, audacity, and determination necessary for truck farming also applies to pineapple growing. Pineapples are the only fruit of great value that did not originate in Florida, and Brevard County led all other counties in pineapple growing. A very uncomfortable crop to handle with its sharp spines, workers had to wear heavy gloves and leggings. (Courtesy of Tebeau Library of Florida History.)

These unlikely fruit pickers had no acquaintance
with the toil and sweat required to get orange and
grapefruit groves started, or then to nurse them
for many years until the first crop was made.
Indian River Oranges are the best on the market
and are known as the Royalty of Oranges.

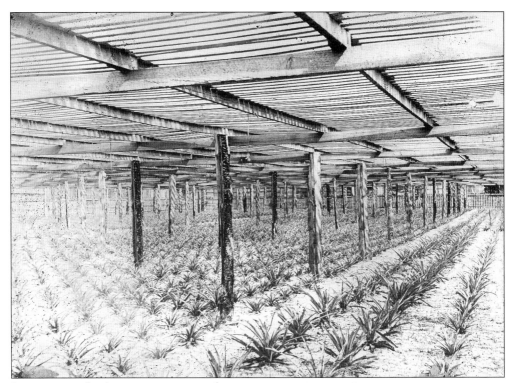

Later, pineapple plantings were covered with lathing and cheese cloth to keep the plants from "scalding" from the sun. It was 24 months from setting out until harvest.

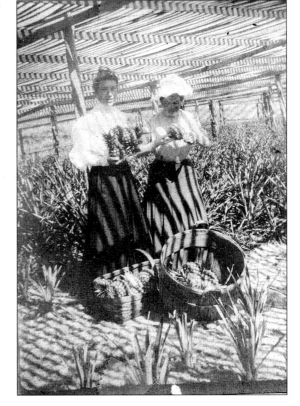

This photo illustrates the shading effect of the overhead latticework in the Beaujean pineapple patch. Cost and time in construction meant that such latticeworks were far from universal. The shade brought mosquitoes that were a torment to the heavily-clothed workers.

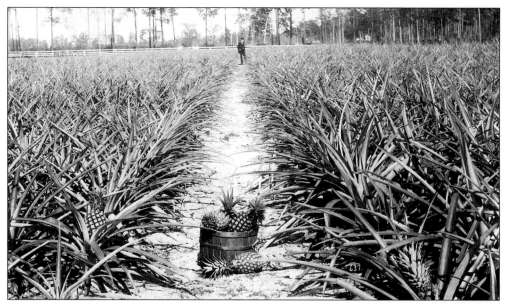

The barrier island side of the Indian River especially attracted pineapple farmers. Some only set out patches, while others who were better capitalized had "plantations." Brevard County was the state's largest pineapple grower. The fact that Indian River and St. Lucie Counties were then part of Brevard had much to do with this distinction. Pineapples, along with citrus and vegetable crops, were wiped out in the disastrous 1894–1895 freeze. (Courtesy of Tebeau Library of Florida History.)

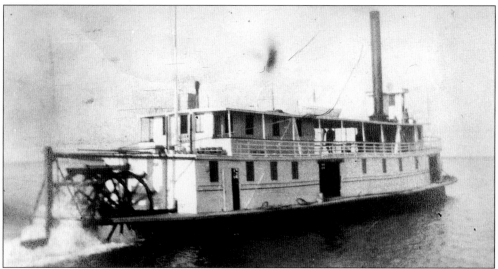

Before 1919 and the opening of Sebastian Inlet, the Indian River was even more shallow than it is now, most would estimate by 18 inches. Docks were built far into the river, and in these isolated years, the store came to the customer. Store boats selling canned food and dry goods were housed in smaller boats that could make their way into a settler's dock. Settlers would leave a signal at the end of their dock if they wanted the boat to stop. Trade boats carried dry goods, tinned food, clothing, and medicine. There was even Dr. Houghton's dental barge. Old-time river merchants were news bearers and yarn spinners who brightened the lives of lonely settlers.

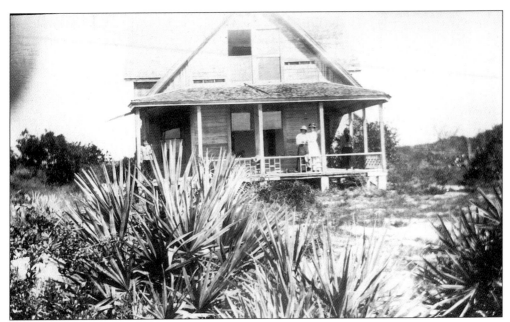

Many settlers, try as they might, simply could not make a "paying proposition" of their river homestead. Here are two views of O.G. Gibbs's home, which he called "Basham," obviously after he had given it up.

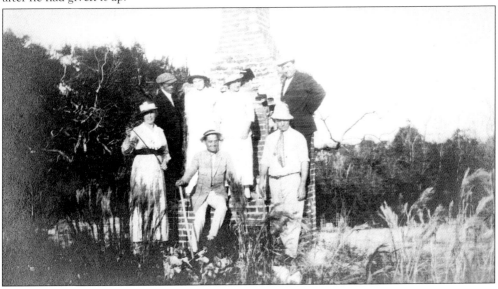

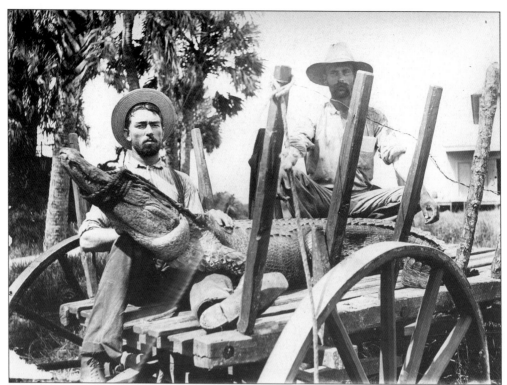

Game of every description struggled for existence on the barrier island. These unidentified men captured an 8-1/2-foot alligator in this c. 1900 photograph. (Courtesy of Brevard County Historical Commission.)

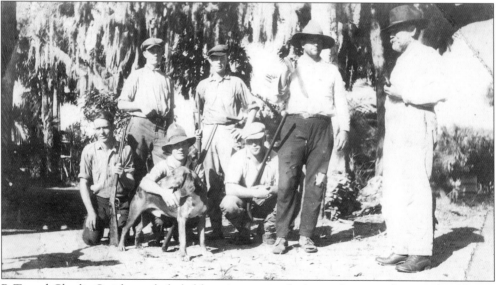

R.T. and Charlie Smith regularly led hunting parties for bears, deer, panthers, and wild pigs. Pigs were especially disliked; they rooted up crops, and additionally, they carried fleas.

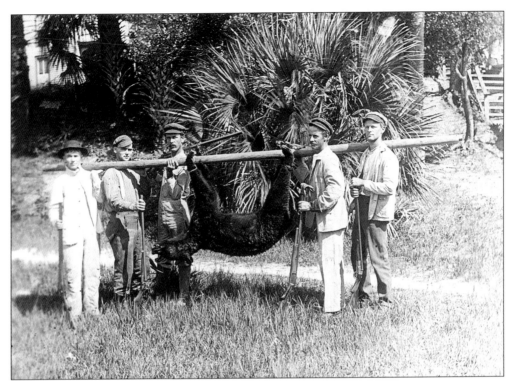

Bears were seen on more than one occasion swimming across the river. In this photo, from left to right, two unidentified hunters, Alex Goode, Claude Beaujean, and Don Beaujean show off a decidedly dead black bear in Melbourne. (Courtesy of Sea Bird Publishing, Inc.)

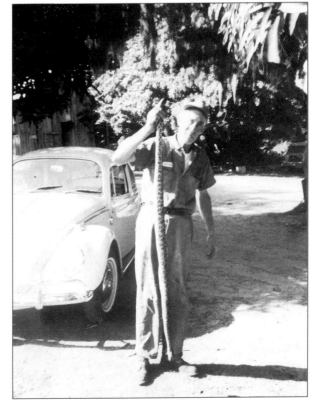

The automobile in the background tells us that Capt. Fred Hope killed this rattlesnake some time within the past three decades.

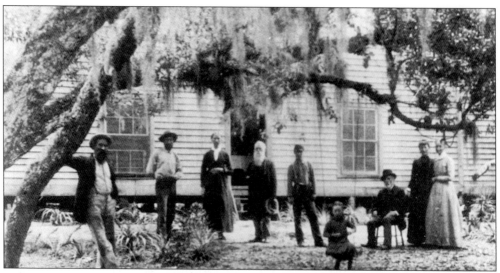

Oak Lodge was a ten-bedroom hotel and boardinghouse that catered to Yankee scientists late in the 19th century. Charles Latham, who barely made it into the Union Army at war's end, obtained a soldier's claim of land of 164 acres and, with his "wife" Frances, moved onto the island in 1881. Charles Latham made a name for himself over the years. Prominent scientist and guest Frank Chapman, of the American Museum of Natural History, noted that Latham's "chief accomplishment is the inexhaustible ability to sit and smoke." Frances Latham added "Charley smokes just once a day now beginning before breakfast." The couple had five daughters. The night of Halley's Comet, May 18, 1910, Oak Lodge mysteriously burned to the ground. This was the second time Oak Lodge burned down. This 1887 photo shows what may be the first Oak Lodge, which burned down in 1893. Standing in the middle are "Ma" Frances Latham and the bearded Professor J.W.P. Jenks of Brown University.

Ornithologist Frank Chapman loved Oak Lodge and its wildlife. He discovered new and rare animal species in the hammocks and mangroves surrounding the tiny settlement. It may be a surprise nowadays that bird experts of this era killed representative types in order to study them more closely.

"Ma" Latham catered to the scientists who came to Oak Lodge. She learned to speak "their language" and became a very informed layman in their area of expertise. To some she appeared "almost like a man."

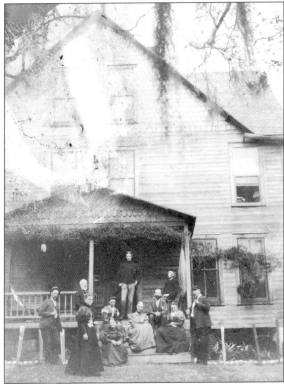

There were two Oak Lodges. The first dates from 1881until 1893, when it burned. The second structure shown here was larger. It lasted until 1910. This group includes Prof. J.W.P. Jenks of Brown University, an anthropologist, who with "Ma" Latham dug up many Native American burial sites.

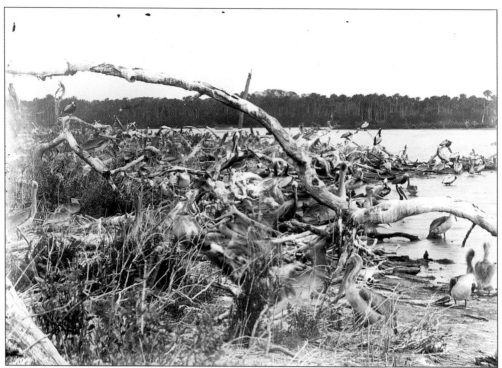

Frank Chapman, well-known writer and ornithologist who stayed at Oak Lodge, was largely responsible for getting this river island, named Pelican Island, designated as the first wildlife refuge. Until this time "manly winter tourists had been urged to bring rifles and shotguns and indulge in sport shooting." This meant aiming at everything from manatees to pelicans. (Courtesy of Paul Kroegel.)

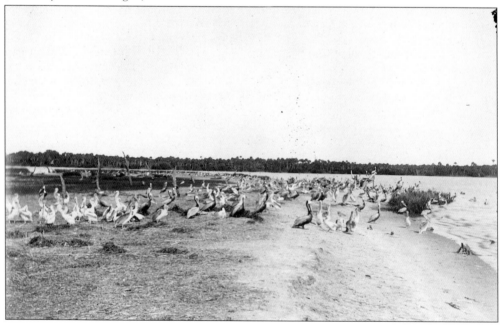

Three
THE BOOM!

Don Beaujean said, "Well, the Boom was big for us." He meant that although it was small in comparison to South Florida, the Boom was nevertheless very real for Melbourne Beach. Raw acreage was bought and sold over and over again, each time at a higher and higher price. Inflated expectations brought inflated prices, and unreality set in. Don Beaujean was experienced and therefore had a much more critical eye than others.

Florida law at this time allowed real estate to be bought on margin, only ten percent down. And that ten percent was usually borrowed or put on credit. The new language of salesmanship set in. Real estate sales agents became "Realtors." These individuals were swell, two-fisted regular guys; they were hustlers who had pep and inspiration and Chamber of Commerce smiles. They were scholarly in regard to salesmanship. Melbourne Beach's 18-mile stretch of prime real estate became the target of zip, zest, and zowie! These all-American go-getters proclaimed that if one had enough vision, one could get rich. Wealth was there for the taking!

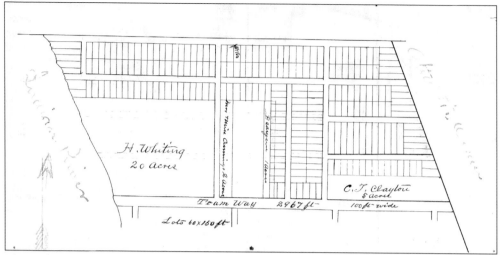

These plat maps date from 1900 and show streets that did not come into existence for many years to come. All lots were 60 feet long, too small by modern standards. Since the original purchasers of this government land only paid $1.25 an acre, the potential for huge profits were enormous.

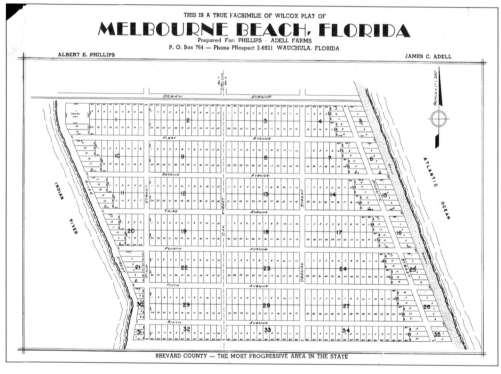

Investors from Detroit, Michigan, seemed to be particularly attracted to Melbourne Beach. John Winter, who married widow Eva Sweet of the Villa Marine Hotel, was an inveterate optimist, as shown in this 1920 rough draft of his large-scale plans. Only two houses were built as a result of Winter's real estate dealings, and they were to members of his own company. Roger Sweet and Peter Milner both built on Sunset Boulevard in the 1920s.

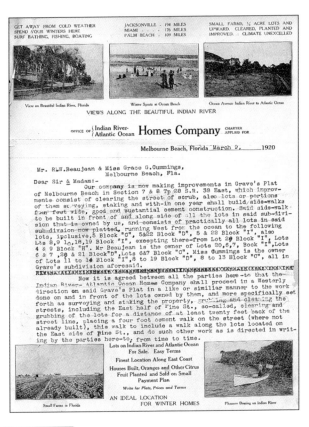

Ernest Kouven-Hoven was among the first to see the potential of beach development. He owned over a square mile of the island opposite Melbourne, including most of what is now the community of Indialantic. This 1917 letter is the opening round in the saga of bringing about a bridge across the Indian River. The promised improvements to the raw rattlesnake- and mosquito-infested scrub included an ocean pier, tramways, and a golf course. (Courtesy of Tebeau Library of Florida History.)

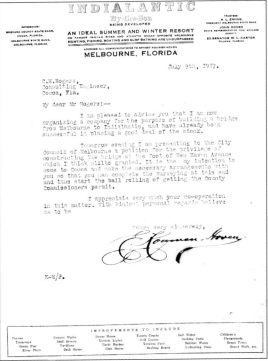

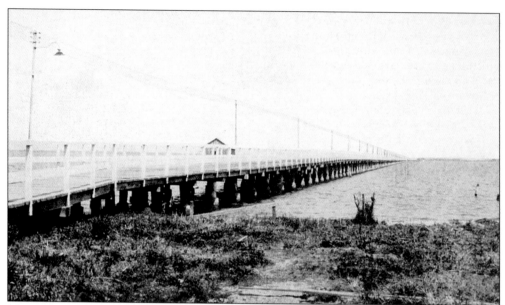

The 16-foot-wide, 1-3/4-mile-long bridge took four years to build from its inception in 1917. It was a toll bridge and always gave the motorist a feeling of instability. A poem of the time goes:

When you drive the Indialantic bridge
Give unto God your thanks;
It may be strong, but it's awfully long,
And antique are its planks!

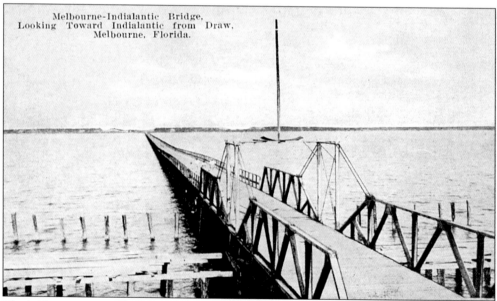

The bridge was opened by human power. The bridge tender pressed all of his weight against the capstan bar. The metal swing span usually took five minutes to open. Sam Martin was a bridge tender who lived many years in a house on the bridge. The bridge was always catching on fire from cigarettes or cigars that were tossed out of vehicles or from careless fishermen who knocked over kerosene lanterns.

42

This is another view of the wooden bridge. With the bridge's width at only 16 feet, one always dreaded meeting a car coming from the other direction; cars had to slow to a crawl and ease past each other.

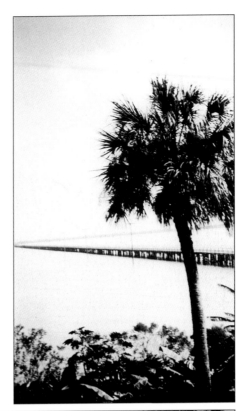

This view shows the approach to the bridge in Melbourne. During WW II, the Army posted guards at either end; no "unauthorized personnel" were allowed on the island. The military was on the alert for enemy agents bent on sabotage who might have come ashore from submarines. After the war, the public found that the military had indeed had cause to be on alert. Five German agents had come ashore near Jacksonville early in 1942, and only by luck were they caught before damage was done.

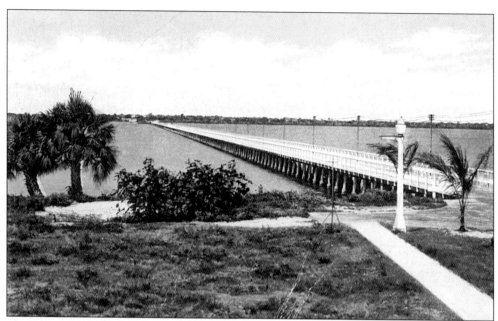

The State Highway Department took over the bridge during the Depression of the early 1930s. Lobbying efforts immediately began for a new, safer causeway and bridge. Note the power lines that take electricity to the beach. Power finally came in 1926.

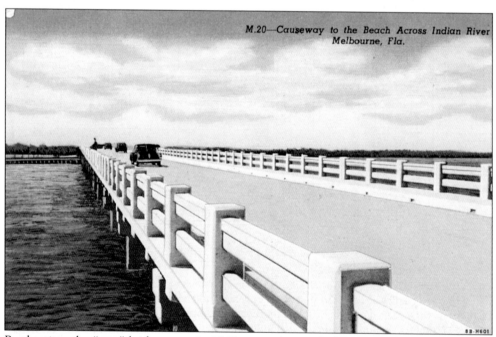

M.20—Causeway to the Beach Across Indian River
Melbourne, Fla.

By the time the "new" bridge came in 1947, great changes had come to the island. Miles of asphalt streets had been laid. Islanders no longer felt so isolated.

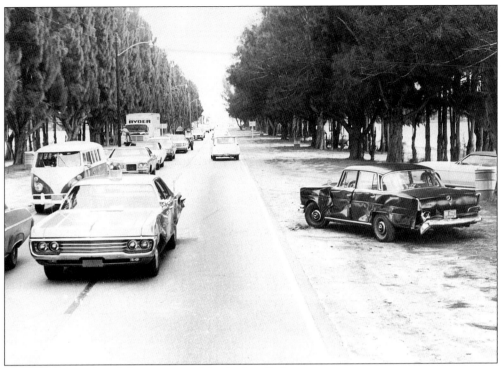

Australian Pines lined the area east of the bridge all the way up to the relief bridge. Unfortunately this particular variety of Australian Pine propagated by sending out suckers, thus creating a bad impression for the trees in general. (1973 photo by Julian Leek.)

This news story from the *Melbourne Times* in August 1925 is in many ways typical of the "land delirium" that was seizing Florida during the Boom. Although purchasers usually proclaimed their intentions to develop their new property and led neighbors and newspapers to believe so, such promises were, as the *Indian River Advocate* stated in the 1890s, "composed mostly of gas."

MANY TRANSFERS OF OCEAN FRONT PROPERTY HERE

8/29/25

Beaujean Sells $443,-100 Worth of Property at The Beach.

TO BE DEVELOPED

Purchasers are Capitalists Who Will Carry Out Program.

Don R. Beaujean, Melbourne realtor, Friday announced the sale of property in Melbourne beach totaling $443,100.

The announcement of these sales came as important news to people of this vicinity for it means that a great deal of property in and around Melbourne Beach will be developed.

Among the buyers were F. W. Birdsong and associates of Lake Worth. He purchased three ocean front tracts south of Melbourne Beach aggregating 140 acres. P. H. Shaffer of Chicago, who plans extensive developments, bought 80 acres four miles south of Indialantic.

A. J. Coe of Medina, N. Y., purchased a few choice pieces of ocean front property in Melbourne Beach, two blocks north of the casino.

W. J. Breen, of 'Grand Rapids, Mich., also closed a deal with Mr. Beaujean for 22 acres in South Melbourne Beach extending from the Indian River to the ocean. Mr. Breen also became the owner of the entire tract of land that has been known as the property of the Melbourne Beach Company. He purchased all unsold lots for a half a mile south of Ocean Avenue and the property of this company extending from Indian River to the ocean.

In the 1940s and early 1950s land prices became a bit more realistic. The Murphy Act of 1937 put land on the market that had been abandoned by its owners and allowed purchasers to buy the land by paying off the taxes that were owed on it.

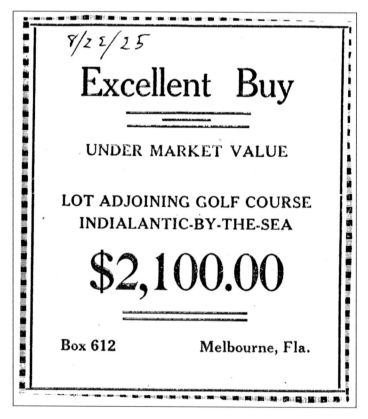

This was a full page advertisement in the *Melbourne Times*. Its simplicity belied most real estate advertising of the 1920s. Promotional writers blew holes in the English language in their efforts to outsell competitors. Buyers usually had no intention of developing the property; they would simply turn around and at a profit sell to a newcomer in the real estate game. He, in turn, would sell. On and on prices would spiral in a frenzy of wheeling and dealing.

Few of these lots were sold. It would take another 35 years and a Space Boom economy to match these prices. Hope for enormous profits clouded out reason and reality in the minds of many promoters. This unreality extended to the minds of a few buyers, but not many.

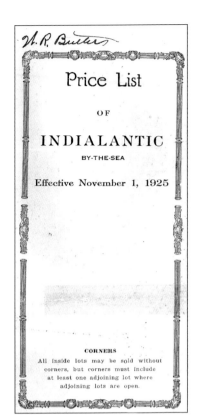

Price List

OF

INDIALANTIC
BY-THE-SEA

Effective November 1, 1925

CORNERS

All inside lots may be sold without corners, but corners must include at least one adjoining lot where adjoining lots are open.

BLOCK 53
14	2,000.00
15	1,900.00
16	1,900.00
17	1,900.00
18	1,900.00
19	1,900.00
20	1,900.00
21	1,900.00
22	1,900.00
24	2,125.00

BLOCK 54
1	2,100.00
3	1,875.00
4	1,875.00
5	1,875.00
6	1,875.00
7	1,875.00
8	1,875.00
9	1,875.00
10	1,875.00
11	1,925.00
12	Withdrawn

BLOCK 55
12	Withdrawn

BLOCK 56
1	Withdrawn
2	1,850.00
3	1,650.00
5	Withdrawn
6	1,900.00
7	1,875.00
8	1,875.00
9	2,950.00
10	2,800.00
11	2,650.00
12	2,500.00
13	2,200.00
14	1,975.00

BLOCK 57
1	Withdrawn
2	1,975.00
3	1,925.00
4	1,925.00
5	1,925.00
6	1,925.00
7	1,925.00
8	1,950.00
9	1,950.00
10	1,950.00
23	1,950.00
24	Withdrawn

BLOCK 58
1	Withdrawn
3	1,975.00*
4	1,975.00
5	1,975.00
6	1,975.00
7	1,975.00
24	Withdrawn

BLOCK 59
1	Withdrawn
24	Withdrawn

BLOCK 60
1	Withdrawn
24	Withdrawn

BLOCK 66
1	22,000.00
2	19,000.00
3	19,000.00
4	19,000.00
5	19,000.00

BLOCK 67
1	15,500.00
2	9,000.00
3	8,000.00
4	8,000.00
5	8,000.00
6	8,000.00
8	8,500.00
9	8,500.00
21	9,560.00
22	9,250.00
23	9,250.00
24	8,600.00
25	8,250.00
26	12,500.00

BLOCK 69
11	2,050.00
12	2,200.00*

BLOCK 70
15	2,950.00*

BLOCK 71
13	2,550.00
15	3,150.00

BLOCK 73
9	9,000.00

BLOCK 74
5	2,850.00

BLOCK 76
6	3,000.00
10	4,900.00
20	5,500.00

BLOCK 77
12	4,900.00
14	7,500.00*

BLOCK 78
1	4,750.00
15	2,025.00
23	4,250.00
14-15 Combination	7,975.00

BLOCK 79
2	2,025.00
10	5,850.00
14	2,150.00
1-2 Combination	7,000.00
11	2,050.
12	1,850.
13	2,150.

BLOCK 80
1	5,450.00
9	1,975.00
11	2,950.00
15	2,050.00
20	1,975.00
23	2,600.00*
10-11 Combination	8,500.00
20-21 Combination	6,300.00
12	5800
13	3850
14	7050

BLOCK 81
1	4,500.00
10	1,775.00
12	7,000.00
13	1,925.00
19	1,925.00
22	1,950.00
22-23 Combination	6,500.00
12-13 Combination	8,925.00
14	1925
15	1925
16	1925
17	1925

BLOCK 82
1	4,600.00

BLOCK 84
8	5,200.00

BLOCK 85
12	5,200.00
23-24 Combination	8,500.00
23	2,500.00

BLOCK 86
13	5,200.00
14	2,800.00
22	2,200.00
14-15 Combination	7,300.00

BLOCK 87
2	2,000.00
8	2,500.00
9	5,275.00
13	2,100.00
12	5,375.00

BLOCK 88
2	2,125.00
10	5,375.00
11	2,350.00*
13	5,275.00
14	2,025.00

BLOCK 89
11	2,025.00
13	2,250.00
14	2,250.00

Lots marked * are under option.

Lots marked * are under option.

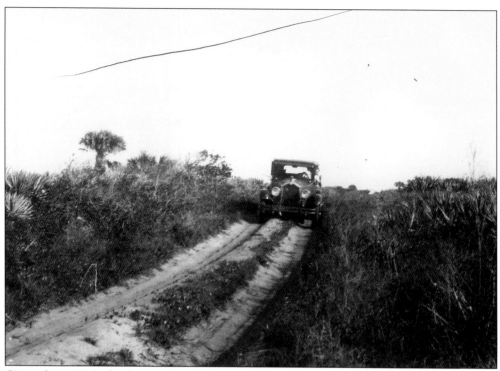

Going down A1A checking out real estate, it was a good idea to keep moving and stay in the tracks. (Courtesy of Hollis Bottomley Collection.)

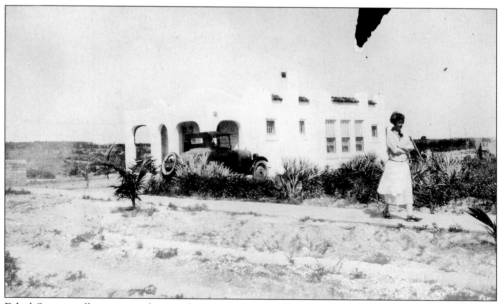

Ethel Sweet walks on a newly paved section of sidewalk toward the deserted ocean front.

Roger Sweet and his wife, Ethel, sit on the porch of their new bungalow on Sunset Boulevard in 1928.

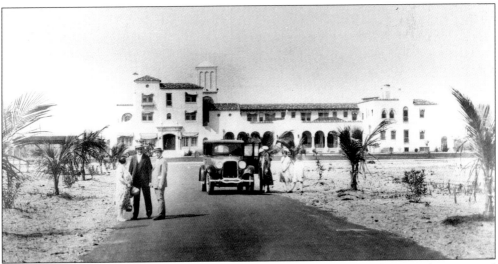

The building and the selling of Hotel Indialantic (named The Tradewinds in 1940) represented the apogee of 1920s optimism. Ernest Kouwen-Hoven made the deal with Herbert R. Earle, who represented a group of Detroit businessmen willing to build the very latest in high class resorts that would rival Palm Beach and Hobe Sound. The hotel cost $350,000, and its opening on February 2, 1926, was the social event of the year for all of South Brevard. The hotel featured tennis courts and a nine-hole golf course. During the Depression years from 1932 to 1934, the hotel was closed. When it reopened in 1935, the golf course had disappeared under an onslaught of palmettos and bushes. Karl P. Abbott of New York bought the hotel in 1940, changing its name to The Tradewinds. Abbott also wanted to call the then unincorporated town of Indialantic "Bahama Beach," but locals strenuously objected. Changing times and tastes finally brought the wrecking ball to this once grand hotel. The land, located on the west side of south Shannon Avenue between Eighth and Twelfth Avenues, was worth more as residential real estate.

From the tone of this advertising booklet one can tell the resort is modestly successful.

Indialantic
BY ⁕ THE ⁕ SEA

*T*HIS booklet of half-tones is prepared as a "progress report," showing some of the work done in recent months at Indialantic By-the-Sea. We cannot show the many miles of street pavement nor all of the other work accomplished. We should like to show you pictures of some of the houses and one or two flats that have recently been built, or which are in course of construction, but we have decided to wait until the completion of the beautiful C. P. Singleton and Richard Henley homes, also the eight-family apartment building and the home on Tampa Avenue which are being constructed by Mr. F. F. Bennett.

Some of those who have finished homes during the past few months are Mr. and Mrs. Chiles P. Plummer (two-family apartment); Mr. and Mrs. W. M. Christen; G. R. Tyler and H. B. Rose (two-family apartment); Mr. and Mrs. Walter Church; DeWitt C. Baker; Mr. and Mrs. Fred Kemper; Mr. and Mrs. D. E. Newton and Mr. and Mrs. George W. Hight, Jr. We do not refer to many homes previously erected.

Last year, on account of difficulties in obtaining materials, home-building was not urged; but now, labor and material conditions are very favorable and we expect to see the erection of homes and apartments take greater strides. Places for rent are in demand both in winter and in summer.

Hotel Indialantic was opened last winter, as promised, and had a most successful season. The golf course was also in quite surprisingly good condition.

Later in the year a booklet of Indialantic house pictures may be furnished.

Pictures tell the story somewhat. They do not show colors—these your imagination will have to supply.

H. R. EARLE

Most of the homes mentioned here are still with us, though in most cases extensive remodeling has taken place.

The slate floors were brought from Vermont. Other parts of the hotel were of the latest fashion.

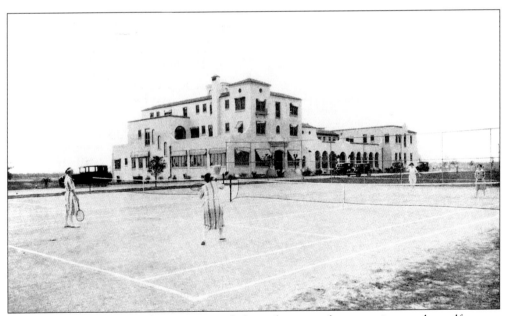

These Hotel Indialantic clay courts needed nearly as much pampering as the golf course pictured on the next page.

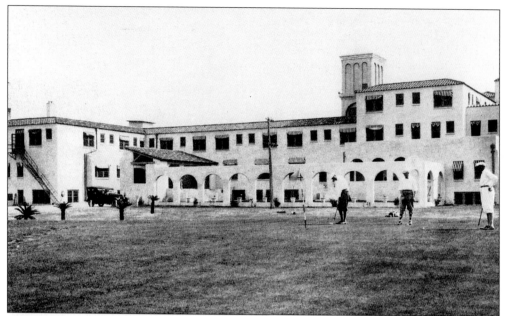

Left unclear is just how much upkeep the nine-hole golf course received. During half of the year the Florida sun is brutal on lawns and plants.

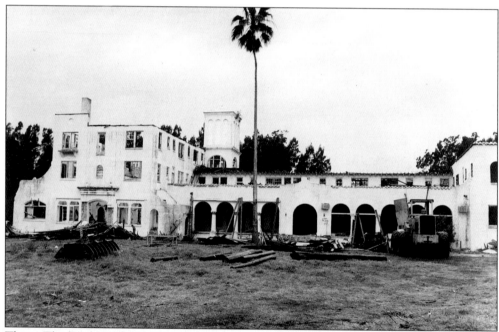

This is The Tradewinds Hotel in 1983. For a time, it had remained afloat as a cocktail lounge, and then as a college dormitory, but obsolescence could no longer be denied. The land was too valuable to remain unused and today is the site of several beautiful homes. (Photo by Julian Leek.)

To the right is the beginning of Riverside Drive. It did not extend through to the south until WW II, when German submarine activity made coastal blackouts necessary.

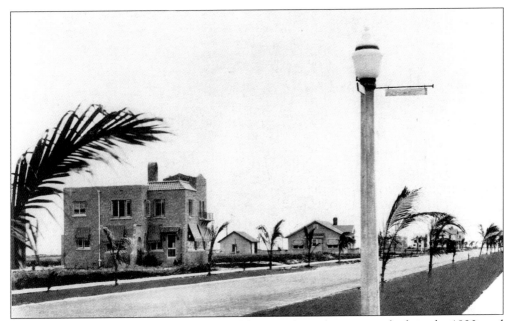

These Fifth Avenue structures are recognizable. Two dozen homes were built in the 1920s and are scattered all about the community.

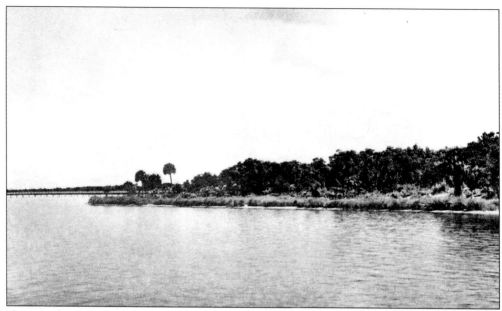

Two conflicting stories tell how Indialantic-By-The-Sea got its name. The area had been known as "East Melbourne." One story relates that the name was chosen as a result of a contest in the *Melbourne Times*. Another, and probably the truer one, is that Ernest Kouwen-Hoven and H.R. Earle named it.

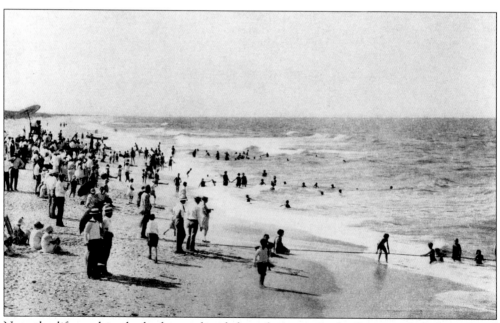

Note the lifeguard in the background and the safety rope in the foreground. Only a special occasion would have brought this crowd and these precautions.

54

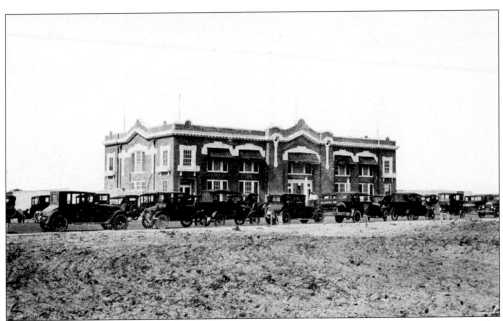

The two casinos pictured here were built in 1924. They were recreational facilities for the whole family and had nothing to do with gambling as the word "casino" now implies. Both featured artesian, sulfur-water swimming pools and changing rooms. Both establishments underwent similar changes, and lasted about the same number of years. By the 1960s, neither of the sulfur-water swimming pools could meet more stringent health department requirements. For a while the more northern of the two became a private club calling itself "The Bahama Beach Club." Then it became public for a short time as the "Bikini Beach Club." Both casinos lost the family atmosphere they had once enjoyed, becoming strictly drinking establishments catering to that limited clientele. Both casinos had outlived their day by the early 1970s. One was lost to the wrecking ball and the other to fire.

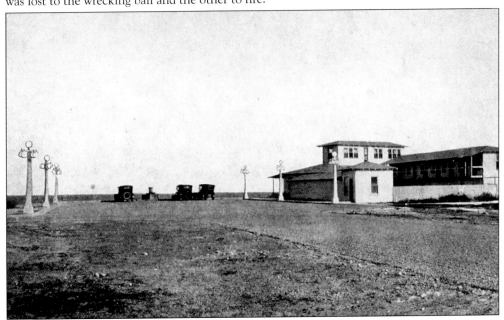

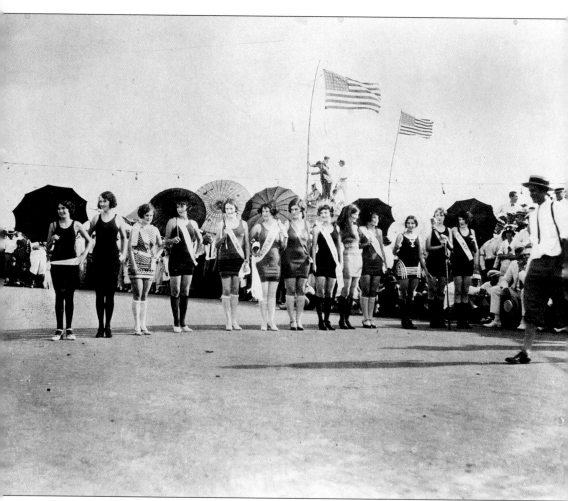

On the Fourth of July in 1925, Indialantic held a "statewide" beauty contest on the waterfront at Fifth Avenue. These ladies were rather scantily clad for their day. Note the knickered, straw-hat-and-tie-wearing fellow coming into the picture on the right.

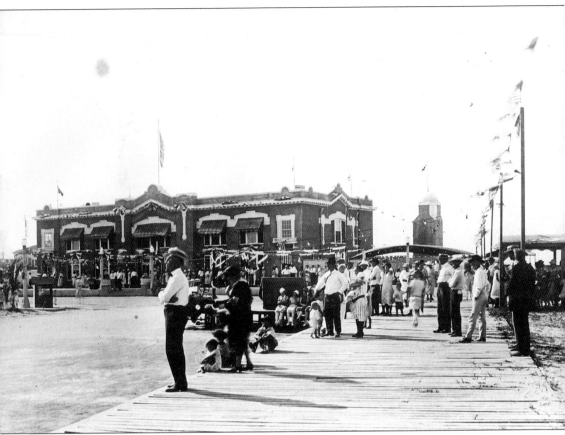

This is a view of the Fourth of July, 1925 crowd. The casino in the background had nothing to do with gambling. The word simply meant a room or building set aside for recreation and "good clean fun." This casino pool was competition size, and over the next two decades local championship meets were held.

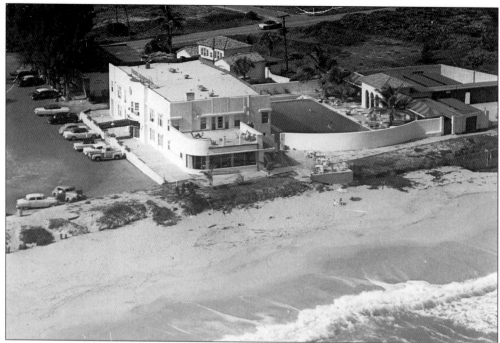

Photographed from the air, this 1950s photo shows the Bahama Beach Club still operating as a private club.

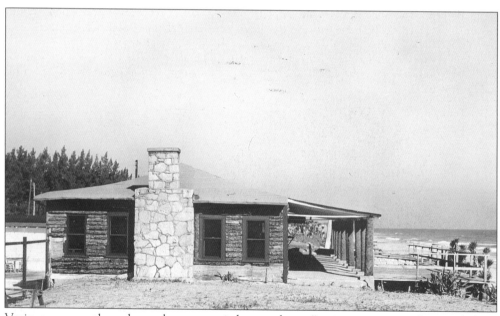

Various owners throughout the years tried to make a "paying proposition" out of these establishments, but the increasing cost of upkeep on the old structures made this more and more difficult. The two casinos oozed atmosphere and ambiance but patrons now wanted the atmosphere air conditioned. When this 1945 photo was taken the Ocean Avenue casino was serving as the petty officers club from Melbourne Naval Air Station.

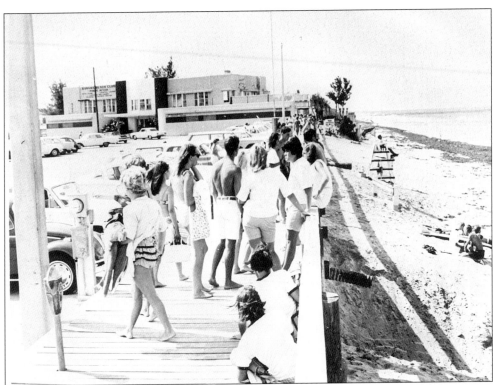

These are two of the last photographs of the two best-known, ocean-front establishments in south Brevard. The buildings became obsolete and the cost of renovation prohibitive. A real debate took place on how best to use the land after the Bahama Beach Club (above) was demolished. Finally, after much turmoil, it became the lovely beach-front park that it is today. The Melbourne Beach Casino (below), site of the original bathhouse, is now a parking lot for Boomerang's Restaurant just to the south. (Photograph below courtesy of Sea Bird Publishing, Inc.)

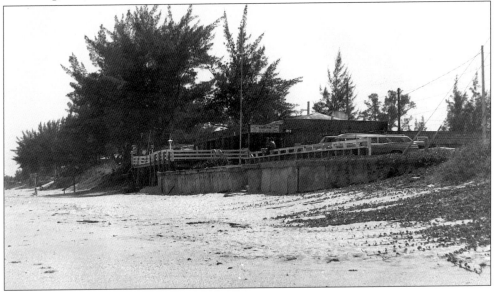

Some have said that the October 1973, rather suspicious fire that destroyed the Melbourne Beach Casino put this landmark out of its misery. It was quaint and rustic, but it had ceased to draw a large clientele. (Photo by Julian Leek.)

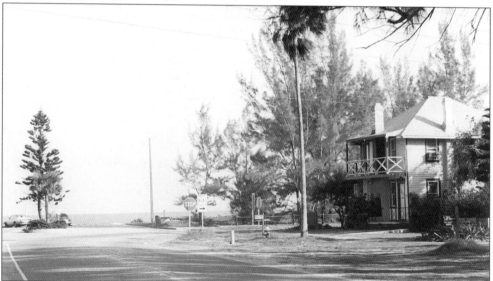

By 1983, almost no sign remained of the historic Melbourne Beach casino. To the right in this photo is the home and law office of George and Sheryl Schmitt, known for many years as "The Pinky Brown house." It was constructed in 1916. (Photo by Julian Leek.)

Four

COMMUNITY ACTIVITIES

The Melbourne Beach and Indialantic communities have always had a strong record of civic participation. From the very beginning, the American tradition of self-reliance and volunteerism has resulted in street beautification, parks and recreation, numerous ad hoc committees, town boards, volunteer fire departments, and youth activities. A pleasant result of this volunteerism over the years has been to keep taxes low. Local residents have never been ones to call on big government to do what they were willing to do for themselves.

For the past 40 years, the Beach Gardeners and the Indialantic by the Sea Garden clubs have been the most consistently active in bringing about a more beautiful community. Currently, the Community Parks Board is the driving force behind our annual Founders Day, held the first Saturday in May every year. This board also sponsors the Christmas tree lighting held in early December. Since 1966, the volunteer fire department has sponsored a very unique Children's Christmas parade. Children, along with some parents, make their way up and down Ocean Avenue in a singular joyous observance that only Melbourne Beach has. Since 1976, Founders Day has begun with the Pineapple 10K race and ended with a street dance. A dozen or so vendors provide food and drink, while an art show takes place in the park. Surfing, volleyball, and a sandcastle-building contest take place at the ocean's edge.

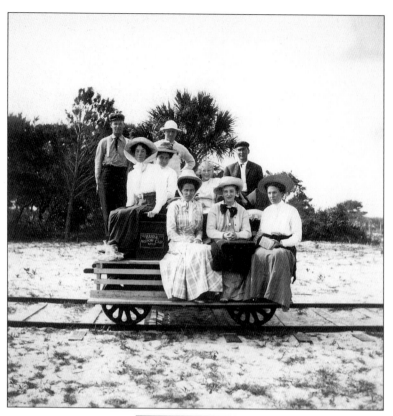

This party is on its way to the pier to take the Melbourne Beach company's excursion boat to the Sebastian River for fishing. Identified, from left to right, are (front row) Mabel Rutherford, Mildred Hicks, and Lida Lawrence; (middle row) all three are unknown; (back row) Don Beaujean, James Dymond Jr., and Claude Beaujean.

Sitting on the front porch of the first Beaujean house and post office, Lida Lawrence and her friend Mildred Hicks are daring Don Beaujean to eat a piece of raw mullet while Capt. Rufus W. Beaujean, on the right, looks on. The sign above the door on the left says "Melbourne Beach U.S. Post Office." A replica of this structure was built in 1991 by the Town Historical Committee and Rick Ritland's shop class at Melbourne High School.

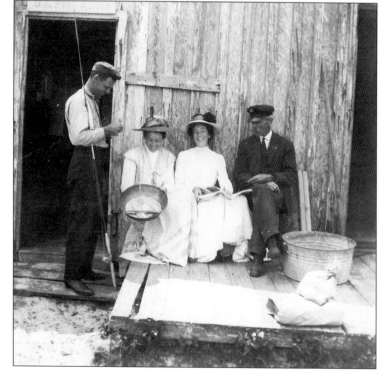

Will and Edna Sim are dressed for a baby party being held at the Woman's Club. Their house was the "50-50," midway between River and Ocean. They made the winter pilgrimage to our community for 40 years. Homemade entertainment, such as it was, had to suffice.

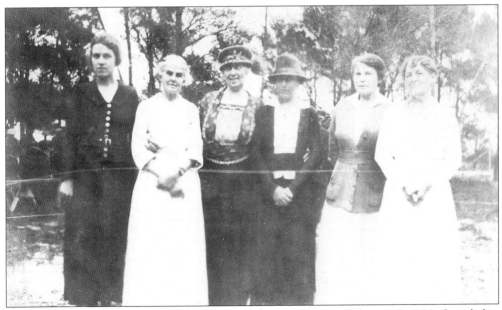

Attending the groundbreaking of the Woman's Club building on February 5, 1920, these ladies were instrumental in the building's completion. The women in white are the Cummings ladies, Hannah and Grace.

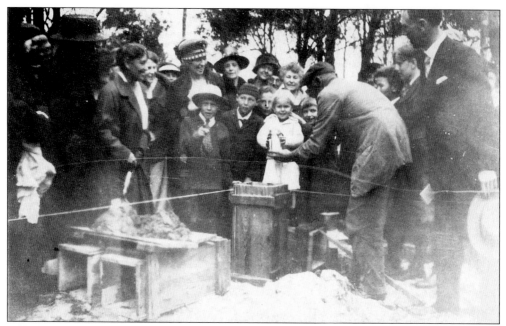

John Alden Beaujean, the first child born in Melbourne Beach, lays the cornerstone at the northwest corner of the building that became our current community center. The cornerstone contained a copy of the *Melbourne Times*, a poem written by Miss Elizabeth Johnson, the minutes of the meeting at Miss Hicks's, at which the vote was taken to build the clubhouse, the names of the officers and the trustees of the building committee of the Ramblers Club, the names of 15 children at the beach, a penny for each child, and the first donation to the clubhouse fund by the firm of Oliver and Starns, earned by picking up driftwood and selling it.

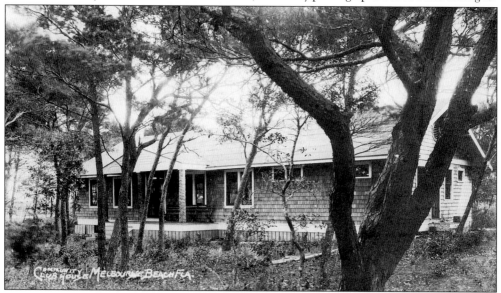

The renowned Woman's Club was the center of social activity for the community. Originally called the Ramblers Club at it formation in 1915, the name change came in 1920. Members' efforts to better the community resulted in concrete sidewalks to the ocean and the construction of what later became this community center.

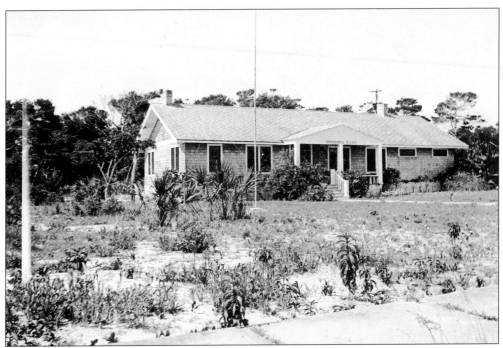

The Woman's Club building, pictured here c. 1950, has always been a center for community activities. It was constructed in 1920 by Grau Builders at a cost of $5,200, an amount raised locally by no more than a few dozen citizens. Card parties, dinners, and dances all attracted community support. In 1954, there was a close call with fire. The interior of the building was in flames when Police Chief Sid Ballard saved the day. He single handedly quenched the blaze using the volunteers' new army surplus firetruck.

In this c. 1921 picture, two New England Dance and Drama students strike an arabesque in front of what is now Murray's Coffee To a Tea on Ocean Avenue. Note the railroad tracks behind them.

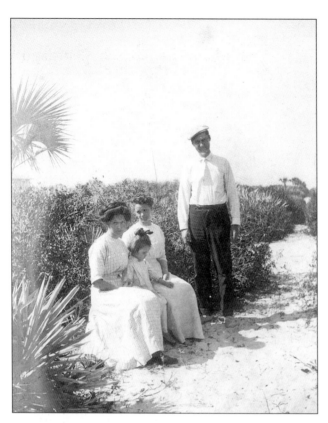

This family is resting on a path from the river to the ocean in 1909. In this more formal era, even when activities required a certain amount of physical effort, ladies and gentlemen adhered to a rather rigid dress code. Note that the gentleman escort is wearing a tie.

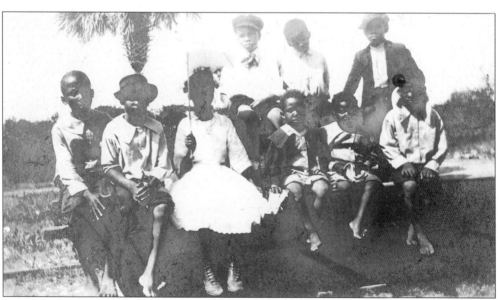

African-American children from Hopkins, the segregated Union Cypress mill town south of Crane Creek, enjoy an annual outing on Emancipation Day in this *c.* 1910 photograph. Thanks to the noblesse oblige of the Melbourne Beach community, the children enjoyed a free ferry ride and picnic.

For several years during the 1920s, Joe Cook, a newspaper columnist from Syracuse, New York, took his winter vacation in our community and produced a newsy, humorous newspaper. He was married to Doris Stillman.

Melbourne Beach Sandspur
"It Covers the Beach"

Vol. 1, No. 12. MELBOURNE BEACH, FLORIDA Thursday, March 21, 1929.

PRICKERS
By Joe Beamish

THE HOME STRETCH
—is generally indulged in right after waking up in the morning.

* * * * *

As this is the last time we shall write "Prickers," we sincerely hope none in the audience has been pricked. We trust your sense of humor has been large enough to overlook little things.

* * * * *

Some girls are like a pair of sixes. They're hard to shake.

* * * * *

The 4 Horsemen have consented to sing in the local chapel next Sunday. They will offer a cantata entitled, "She Was Only a Bar-Tender's Daughter, But, Oh, How We Love Her Mug."

* * * * *

DOGGONE!
I wandered in a garden,
To browse and see the flowers;
I skipped in there, quite unaware,
To pass away some hours.

The roses were in bloom,
Such colors! pinks and reds;
My heart was gay, as on my way
I gazed at flower beds.

I wandered into a garden,
But shot right out with fear,
A bulldog's teeth got underneath
My trousers in the rear!

* * * * *

We Should Say, Sew
Shouldn't a woman's sewing circle be called a—mends club?

* * * * *

A Little Advice
We warn you never
Refer to a woman's
Age except by long
Distance.

* * * * *

"Aw, give a fella a chance," I says to Mrs. Oliver, who was selling tickets on a quilt.

* * * * *

IF AT FIRST YOU DON'T SUCCEED
BUY, BUY AGAIN
This is a story of a man and his wife, occasioned by the word, "buy."
(Continued on Page 2 Col. 2)

PAGE ULYSSES!

This issue of THE SANDSPUR is the last one of the season, which in itself is a cause for celebration. Therefore the staff has attempted to make it a jubilee number.

Herewith it is offered to subscribers as a gift, a free gift. All obligations to both subscribers and advertisers were fulfilled with the appearance of publication number ten, so that eleven and twelve constitute a bonus.

Did somebody once say something about not looking a gift horse in the eye—or was it the mouth?

INFORMAL TEA WILL BE GIVEN AT CASINO

An informal tea will be given from three to five o'clock Saturday afternoon at the Casino for the benefit of the Sunday school.

Miss Norma Ballard and Miss Louise Large will be in charge of the affair. Tea or fruit punch, sandwiches and cake will be served at the cost of 25 cents per person.

The event was planned as the result of a vote of members of the Sunday school last Sunday. They also expect to provide a booth for the sale of Easter cards at the tea.

SNAKE SERUM PROVIDED

The rattlesnake serum which was donated to the Beach by Mr. H. L. Shriver of New York has been placed in the office of the town clerk, where it will be accessible to all residents at all times.

The supply on hand is sufficient for two doses. Full directions for administering the antidote accompany it.

INDIALANTIC HOSTS TONIGHT

Members of the Indialantic Community club will be hosts to the people of Melbourne Beach this evening at the Indialantic Casino.

Cards and dancing will provide entertainment. Those who desired to dance are requested to dress in attire appropriate for a beach dance.

BIBLE SCHOOL SENDS OFFERINGS TO KOREA

Children of the local Sunday school send their special Easter offering to Korea, each year, where it is used for the purpose of assisting in the work of educating Korean children. This season a consignment of Easter greeting cards will be sold by members of the school here for this benefit.

The interest of the local boys and girls in the children of Korea was first awakened by Miss Harriet E. Pollard, principal of an academy for girls in Korea, at the time she visited Melbourne Beach in 1927, her furlough year. Later she sent a Korean spoon of beaten brass to each child here.

Miss Pollard is the personal friend of Miss Sue Hopkins of Melbourne and of Miss Janette Trowbridge.

"It was Miss Pollard's story," says Miss Trowbridge, "of the orphan boys of Korea, whose only comfort in winter nights was to sleep with their feet in the hot ashes under the houses, that first enlisted the sympathy of the Beach children in Korea.

Korea, Miss Trowbridge points out, is suffering under the domination of Japan. Famine and disease are prevalent, and there are many homeless and crippled children and orphans roaming the streets, the inevitable result of Eastern immorality, for the people are either Confucianists or Buddhists.

A recent letter from Miss Pollard tells of one girl in particular, a child-widow, who was cared for and educated in the school, and went out a magnetic teacher.

"But for the faith and patience of the American friend who helped this (Continued on Page 5, Col. 2)

SUPPER SCHEDULED FOR NEXT WEDNESDAY NIGHT

"Pot luck" supper will be served at the Woman's club next Wednesday at 6 o'clock for all members of the community.

Each family will bring one hot dish and sandwiches for their own group. The event will be in charge of the social committee for March, headed by Miss Myrtle Ellicson.

This 1928 photograph shows a group of children about to enjoy an Easter egg hunt sponsored by the Community Chapel. Miss Trowbridge, at one time the postmistress, was their teacher. The young girl in the front row on the left is Virginia Ballard.

This is the program of the first Founders Day, which was held on June 6, 1976. Col. Bob Matte was co-chairman.

During the 1976 bicentennial celebration Mayor John Hunt recreated Maj. Cyrus Graves's 1883 landing in Melbourne Beach. Accompanying Major Graves is Town Commissioner Frank Thomas, co-chairman of the celebration.

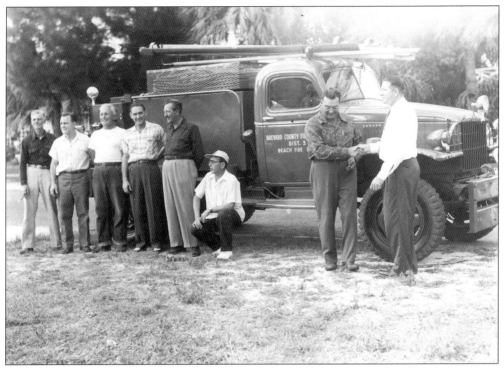

The first fire department on the beach was created in 1953. The fire truck was an Army surplus truck used for fighting brush fires. Bob Wood and Kenny Swentzel were members of that first department.

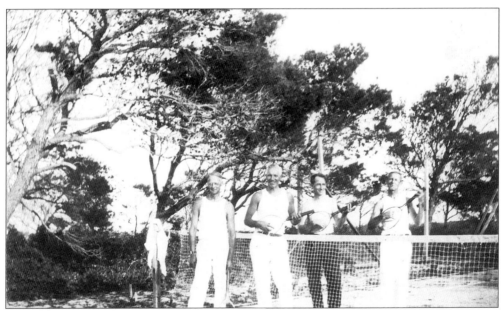

These sporty tennis players have just completed a game. The tennis court was located on the site of the present fire house on Ocean Avenue. The court's surface came from the Ais Indian shell mound half a mile north on the river.

CENTENNIAL CELEBRATION

1883 Town Of Melbourne Beach **1983**
MAY 9-15, 1983

Chairmen
Ex Officio
 Mayor Louis W. Conroy, Jr.
Committee
Ex Officio Members
 Town Commissioners
 Comm. James A. Atkinson
 Comm. Peter J. Knoka
 Comm. Martha M. Remark
 Comm. Robert E. Vaughan
Centennial Planning
Group
Co-ordinator
 Chaplain Roy M. Terry
Secretary
 Mrs. Clare Hamilton
Treasurer
 Mr. Wally Crawford
ARC Rep.
 Mrs. Dorothy Rusen
Souvenirs - T-shirts
 Mrs. Jane Heard
Public Relations
 Mrs. Sue Layton
Centennial Committee
Chairmen
Boating Activities
 Mr. Geo. Behnke
Block Dance
 Mrs. Pamela Terry-Racz
Centennial 10,000
Meter Run
 Col. John Hunt
Centennial Parade
 Mr. Paul Kopp
Churches Committee
 Mrs. Mary Ellen Deppner
Dedication Ceremonies
 Mayor Louis Conroy
Gemini School
 Mrs. Jean Holliday
Golf Tournament
 Mr. Mike Skovran
Historical Committee
 Mr. Franklin Thomas
Kick-off Breakfast
 Mr. Jack Burkbee
Refreshments
 Mrs. Delores Hopkins
 Mr. Kenneth Swantzel
 Mr. Philip Gaardar
Restaurants - Merchants
 Mr. John Belauer
Surfing Contest
 Mr. Curtis Byrd
Tennis Tournament
 Mrs. Jane Block

Dear Friends and Neighbors:

This year in the Town of Melbourne Beach we will be celebrating our "Centennial." One hundred years since Maj. Cyrus Graves acquired the area in 1883 to produce fine pineapples.

One of the largest celebrations that our Town has seen will begin on Monday the 9th of May and conclude on the 15th, Sunday afternoon.

A large number of interesting and entertaining events are being planned which include a Parade, Block Dance, River activities, Pineapple 10,000 Meter Run, Tennis and Golf Tournaments and more which you will learn of later.

One feature of the Centennial will be the publication of a historical book entitled Melbourne Beach: The First 100 Years. It is a delightful account of local history edited by Franklin Thomas, Town Historian, and containing the personal stories of 21 town's people relating their knowledge of our Town's first century. Included are interviews with pioneers Grace Cummings, Don Beaujean, Ruth Ryckman and Lida Lawrence. Their stories are enlightening and often humorous and are accompanied by pictures not heretofore published. The book is being published in hardcover and publication will be limited to 600 copies. Books will cost $10.00 per copy and will be available Centennial Week.

We enclose an order form which may be returned with your check, which will reserve a copy for you. If your check is received by April 5th your name will be listed as a "Centennial Supporter".

Join us in the Centennial Spirit which will reign 9-15 May.

Sincerely,

Louis W. Conroy, Jr.
Mayor, Melbourne Beach

Roy M. Terry, Co-ordinator
Centennial Program Planning Gp.

This 1983 Centennial Celebration was observed to mark the first land purchase of wounded Union Veteran Cyrus E. Graves on the island. The price of the government land at that time was $1.25 an acre.

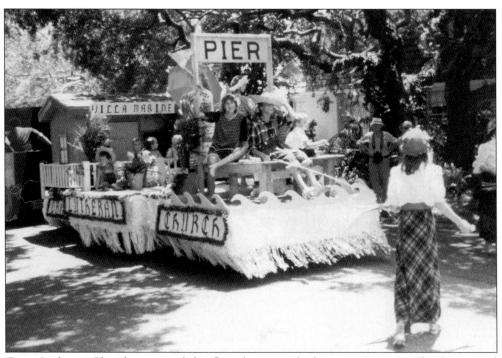

Grace Lutheran Church sponsored this float depicting the historic 1889 pier. The Centennial Celebration was a week-long affair.

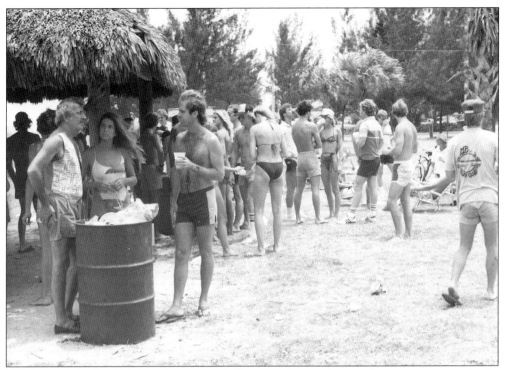

Members of the Surf Club gather in 1979. Centered before the Chickee are teenagers Arnie, Tanya, and Bruce Moia.

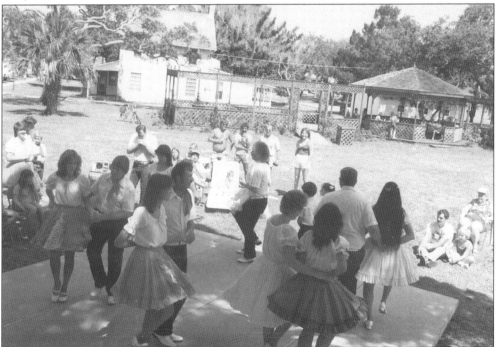

Square dancers perform in Ryckman Park in this 1984 picture. Note the unrefurbished Ryckman House in the background.

Bob Edmund and the Rotarians serve food and beer during the annual Founders Day street dance.

Mayor Bud Conroy presents the sand sculpture award to Robbie Waseleski in this 1984 photograph.

The second Children's Christmas parade in 1967 was organized by Commissioner Richard Wallace, seen in the background smoking a pipe. Mary Long is in the center background, and her daughter, one of the originators of the parade, is the tall elf on the right. Amy and Elizabeth Thomas are the children in the foreground.

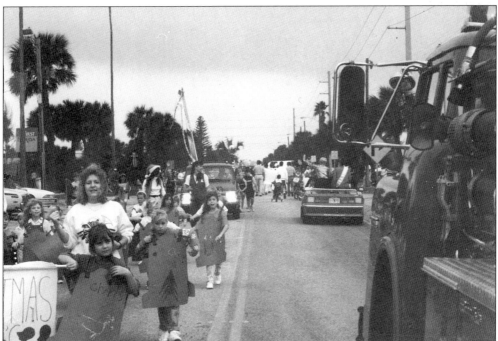

This 1990 photo shows the Children's Christmas parade as it doubles back from the eastern end of Ocean Avenue.

Curtis Byrd's Surf Club entered this very original float renaming the space shuttle the "Surf Shuttle" for the Christmas parade in 1981.

Two of the original parade entrants in 1967 pose with their children in the 1992 parade.

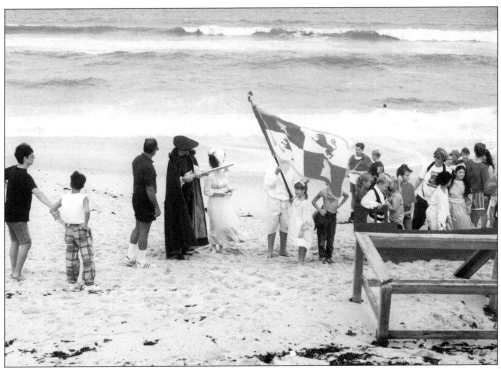

The Quincentennial of Columbus's landing in the new world was observed by a reenactment of Columbus, played by Dave Robinson, planting the Spanish flag. Local residents and students from Gemini Elementary took part in this 1992 pageant. To the left of Columbus is Commissioner Dave Micka.

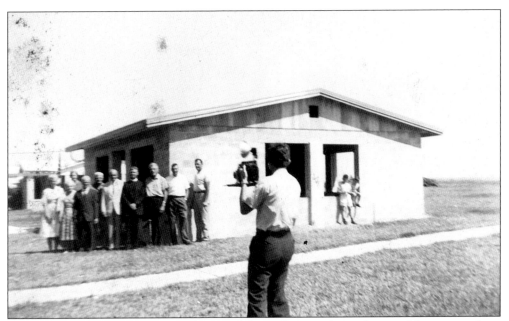

The Floridana Beach volunteers gather to celebrate the partial completion of their ocean-front community building in 1958.

This pretty patriotic "Miss" on training wheels is certainly in training to be a fine citizen. This photo was taken at the 1984 Floridana Beach Fourth of July Parade.

The Beach Gardeners plant Sea Oats in this April 7, 1984 photograph. Pictured, from left to right, are (front row) Bernice Roth and Teresa Campbell; (back row) Bob Vaughn, Annie Hellen Thomas, Donald Tracy, Les Peat, and Mildred Kent.

Five

TWO HISTORIC RENOVATIONS

The first institution any pioneer community wanted was a post office, and these post offices were classified as first through fourth class, depending on the volume of mail. It goes without saying that when our post office was established on December 14, 1891, it was designated as fourth class and housed in what could pass for an attached shed to the side of R.W. Beaujean's house, the first structure built on that part of the island. A combination house/post office was a common practice of that day in small communities. In 1923, the post office took up a cramped 10-by-20-foot section of the old Melbourne Beach Company building, which had been constructed for the stock company's business in 1908. It sat catty-cornered in the park facing the river. It was extensively remodeled in 1923, the year of the town's incorporation, and became the town hall. Mail was delivered twice a day, and the post office became a favorite gathering place for residents. Home delivery of the mail did not come until the 1960s.

Over the years, the Ryckman House had several additions, including a fireplace and chimney, a kitchen, a bathroom, and an enclosed porch. The original 1889 house was really no more than a single downstairs room, a large upstairs bedroom, and a large attic. At one time in the 1980s, the house became so decrepit that the volunteer fire department half seriously suggested burning it as part of a department training session. The Sea Turtle Preservation Society took the house over in the late 1980s with a promise to enhance its appearance. This did not happen. By the time the Ryckman House Restoration began its efforts, this historic structure was in sad shape indeed.

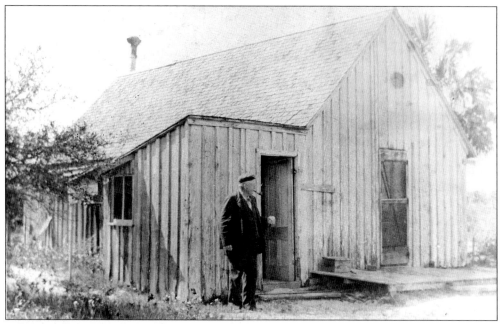

Maj. Cyrus E. Graves, wounded Union veteran and founder of Melbourne Beach, stands before the small attached structure that was the first post office. The larger structure was the home of postmaster, ferryboat captain, pineapple grower, and general handy man Rufus W. Beaujean. The structure was located near the river, bordering the railroad tracks which are just visible on the lower corner of the picture. Major Graves lived until 1912. This photograph was taken in 1908.

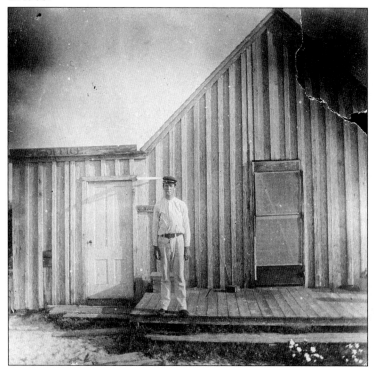

Claude Beaujean stands before his home and the attached post office on the left in this c. 1900 picture. When they were young, he and his brother Don slept in the loft of their home. Claude Beaujean later became Melbourne's fire chief.

In 1989, the original Beaujean house was discovered attached to a larger house that was in the process of being demolished. An effort was made by Frank Thomas, Roy Coyle, and postmaster Sam Tyson to save the historic structure, and it was moved onto the post office property.

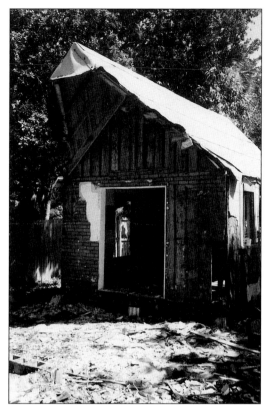

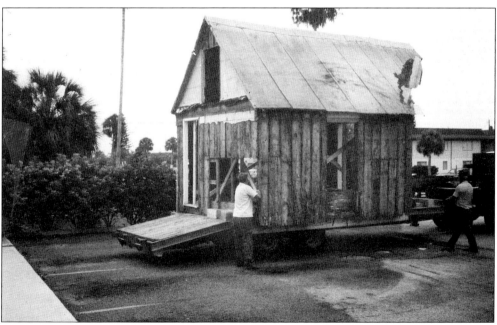

Roy Coyle directs the moving of the first house built on the north beach, the Beaujean house/post office, which dates to 1889. Its condition was too deteriorated for rebuilding, and an exact replica was built.

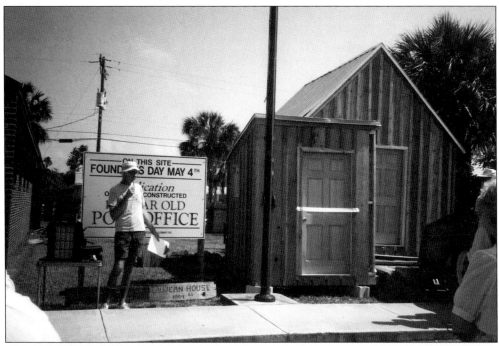

The 14-foot-high replica barely managed to clear power lines as it came to its resting place in time for the planned dedication on Founders Day, May 4, 1991.

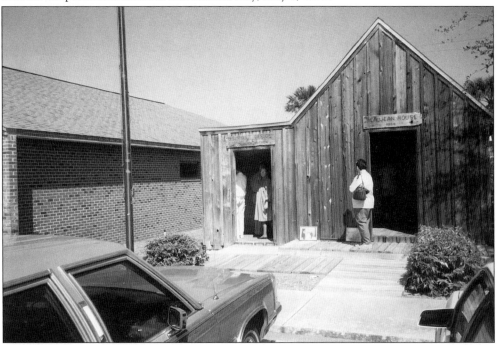

At one time, historical photographs and other artifacts were on display in the building, and the original landscaping was contributed by history-minded locals. In the near future, this replica will be moved into Ryckman Park because of post office expansion. The new site will be nearer to the original site.

Listed on this plaque are the primary contributors who brought about the reconstruction of our island's century-old Beaujean house/post office. Gray Hamilton's foundation work was especially important.

BEAUJEAN HOUSE / POST OFFICE
1889 1891

This structure was made possible by the dedicated efforts of Rick Ritland, Building Trades teacher, Melbourne High School Sam Tyson, Postmaster,
and Melbourne Beach Post Office employees Frank Thomas, Town Historian & the Town History Committee.

Thanks to the South Brevard Historical Society
and the town of Melbourne Beach
for their significant financial contribution.

Thanks to Ronald Chmielewski for the rebuilding plans
Thanks to Gray Hamilton for the concrete and block foundation
Thanks to Bruce & Lois Ingram for the original Beaujean dwelling.

DEDICATION

To these public-spirited townspeople
whose financial contributions made this project possible:

John & Mary Cornell	Randy & Barbara Carmichael
Dennis & Ron Meehan	Basil & Donna Keller
Peter & Julie Koretsky	Arthur & Barbara Person
Mark & Shirley Baccus	Paul & Eva Swindall
Ronald & Lillian Venzetti	Charles & Lillian Brown
James & Teresa Whitten	Marc & Belle Shapiro
Charles & Betsy Baird	Stuart & Sharon Miller
John & Patricia Miller	Philip & Carolyn Elliott
David & Janice Mays	Annie, Amy & Elizabeth Thomas
Ted & Ann Albert	

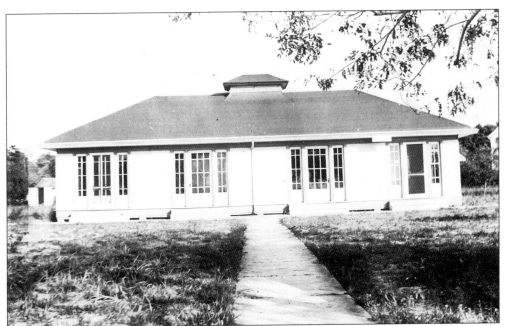

The post office was located, along with the town hall, in the old Melbourne Beach Company building from 1923 to 1953, in Ryckman Park, facing the river.

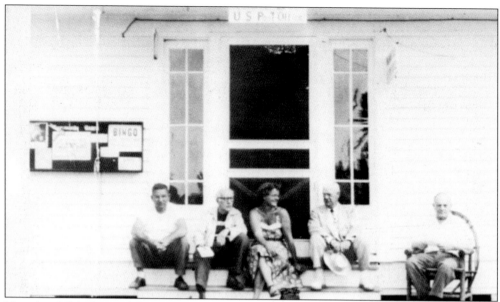

Here, local "Mayberry" folks in 1948 await the twice-daily mail delivery. The gentleman on the right has even been provided a chair. Dick Parsons, a future mayor, is on the left. Fifty years ago, the southern end of the county had its own afternoon daily called the *Melbourne Times*. In the event that someone missed the gossip at the post office, he or she could most likely catch up by reading it in the paper.

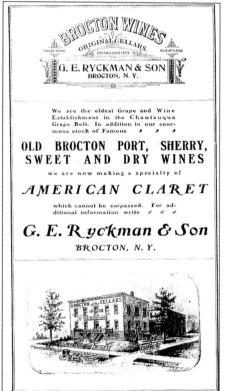

G.E. Ryckman was a prominent vintner in Brocton, New York, prior to his arrival in the Melbourne Beach area.

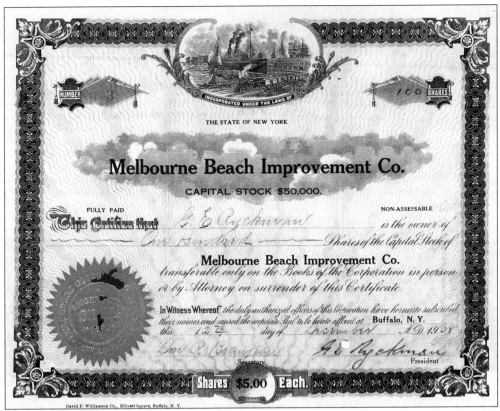

In 1908, G.E. Ryckman bought out the original partners of the company that founded Melbourne Beach and formed a stock company. His investment proved to be a disappointment.

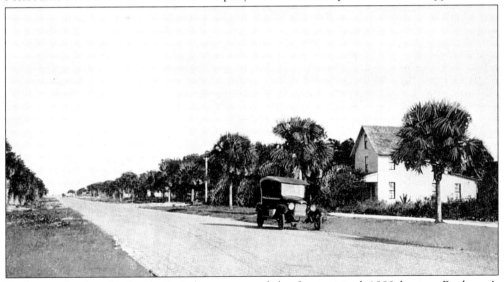

Ryckman also bought Jacob Fox's house, one of the four original 1889 houses. Ryckman's daughter, Ruth, a "maiden lady," lived in the home, which was constructed on town property, until her death in 1979. Restoration of the house began in 1991 through the efforts of the Ryckman House Restoration Committee and the financial contributions of dozens of citizens.

Here, volunteers Ron Marshall and Bill Nicholson are spending their Saturday helping take out later additions to the historic house.

In this rear view of the structure you can see the cistern, which collected rainwater from the roof, and the black tar strip across the back where a kitchen had been added.

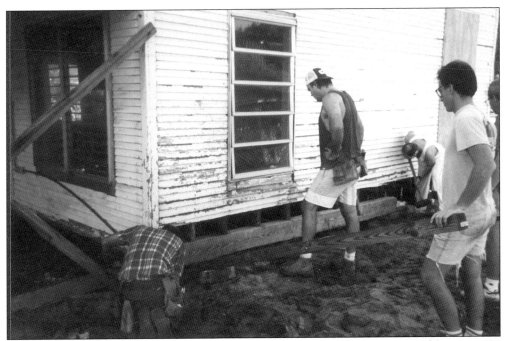

John Marshall (center), Bill Nicholson (far right), and other volunteers replace the rotting sills. Note the original wood siding that has been revealed once the asbestos covering was removed.

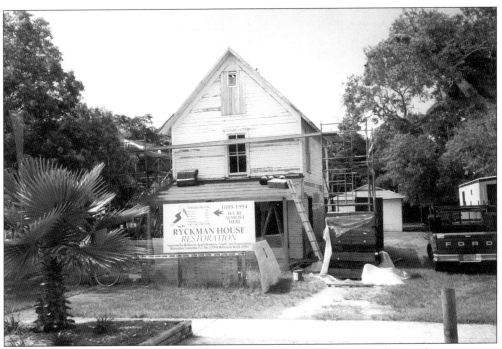

Over 100 individual cash donations, a theater night, a rummage sale, spaghetti suppers, municipal funds, and a state grant all contributed to the endeavor to save the Ryckman House.

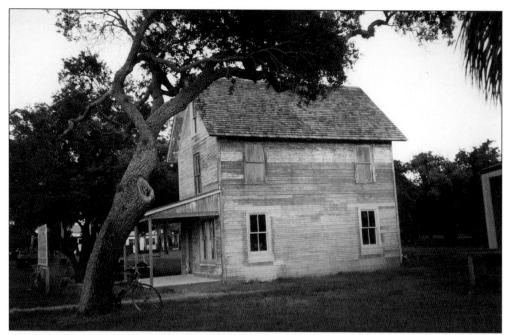

The house is nearing the end of the restoration in this August 1994 photograph. The house boasts new shake shingles, new period windows, and sanding has exposed much of the original siding. Some siding has been replaced.

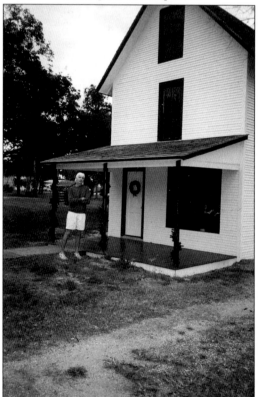

Jacob Fox, G.E. Ryckman, and his daughter Ruth would have been pleased with the results of the three-year effort to save their home. Atlantic Waterproofing and Coating provided the final work in the restoration effort.

Six

TRANSPORTATION

THE FERRY, THE PIER, AND THE TRAM

The first form of transportation in the area was the Ais Indians' canoes. Some of these held up to 30 men. In 1696, Jonathan Dickinson reported seeing canoes with two masts sailing through the inlet into the ocean.

Early settlers also relied heavily on boats. Sailboats always carried paddles and oars in case the wind died. Steamboats carried large numbers of people and valuable freight. An article from the October 18, 1888 issue of the *Florida Star*, which describes pilings being towed down the river, is the first account of a wharf or pier being constructed on the island.

"The steamer *Kathleen* arrived on Monday last with a large raft of miles for the Melbourne and Atlantic railroad wharf. The piling is usually heavy, we believe nearly double that of the ordinary size, being 24 or 25 feet in length and 24 inches in diameter, notwithstanding the high wind of Tuesday, and the rainy day Wednesday, and the fact that a ledge of coquina rock was encountered which had to be drilled, much labor has been accomplished, nearly one third of the piles having been put into position. Major Graves seems to be much elated over the fine progress made. We think it safe to say that the wharf will be fully completed before the rails and locomotive can be gotten through. For the walk across the peninsula which has been the great drawback to the pleasure of a surf bath or stroll on Old Ocean's shell-strewn beach, a short ride in comfortable cars will be substituted."

The few splinters remaining from the original pier qualified this river structure in 1985 for the prestigious National Register of Historic Places.

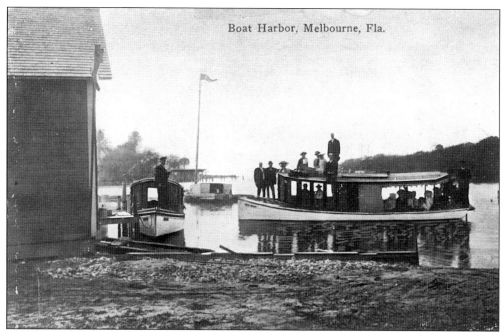

In all, the Beaujean family operated four ferries between 1889 and 1924. The first was the *Adelaide*, which was sail. This was followed by the naphtha-fueled *Jessie B*, and then by the diesel-driven *Ida Mae*, shown here in Crane Creek harbor about 1912. The last ferry was the *Atlantic*, launched in 1918.

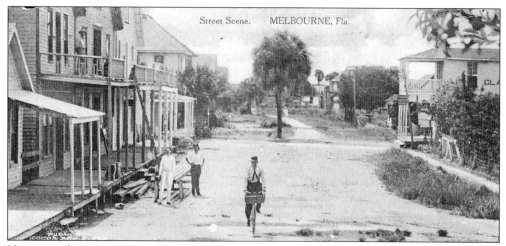

If you sought excitement in the big city across the river, this is what you would find in downtown Melbourne, *c.* 1900. This postcard is showing that town's best side.

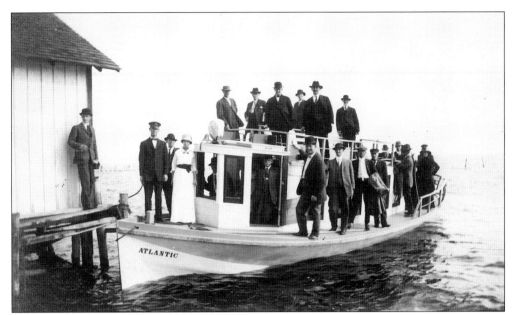

People have sought ways to cross bodies of water since time immemorial. In this 1918 photograph, a boatload of worthy citizens, headed by owner Don Beaujean and his wife, are about to launch the new ferry *Atlantic* on her maiden voyage just over 2 miles across the river to Melbourne Beach.

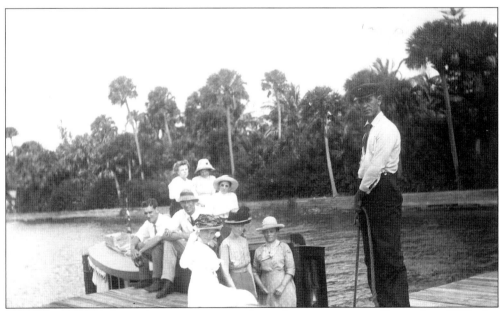

Excursions up and down the river were popular with winter visitors. Pictured in 1915, this group aboard the *Ida Mae* is about to begin the return to Melbourne Beach. The captain is Claude Beaujean.

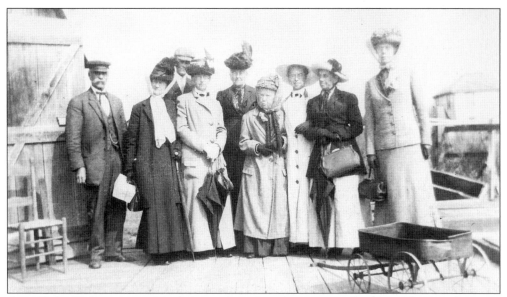

Capt. Rufus W. Beaujean, on the left, stands in this 1912 image with a group about to depart on a shopping trip to Palm Beach, 110 miles south where they will remain for several days. At night the women stayed in hotels, while the men slept on the *Ida Mae*.

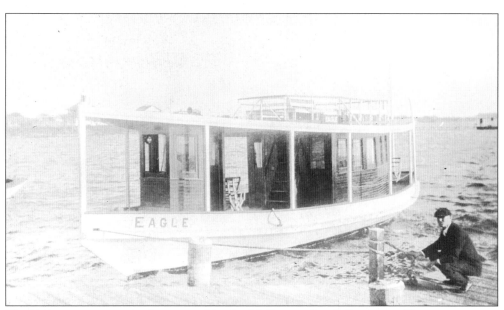

The *Eagle* was an excursion boat owned by the Melbourne Beach Company. This company was formed in 1908 and sold stock after the original partnership of seven western New York partners failed to garner much interest. Don Beaujean captained the boat.

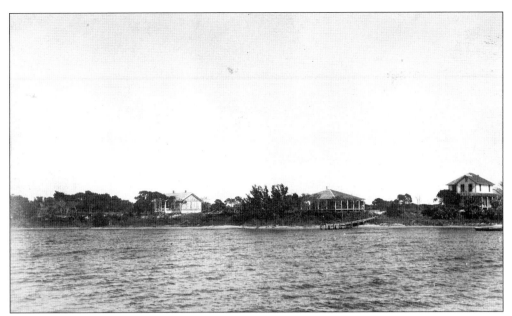

This 1918 scene presents itself as the ferry approaches the island. These homes are still very much with us.

In good weather, the voyage could be quite pleasurable. This c. 1915 picture was taken aboard the *Ida Mae*. Notice how well wrapped the ladies are. Is this for mosquitoes or for the sun?

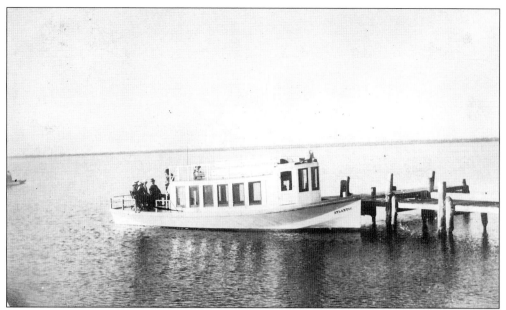

The last ferry, the *Atlantic*, was beamier and heavier than its predecessors but had to be shallow draft. Water at the end of the dock was barely 3 feet in depth.

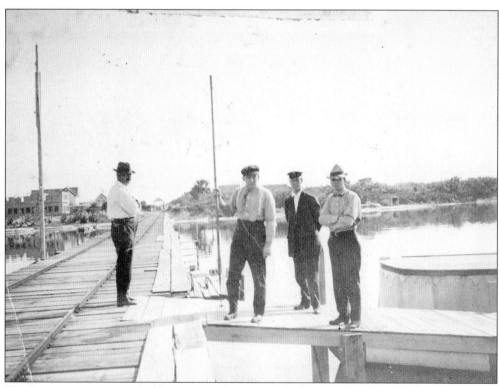

The long pole this man is holding was used to spear fish. The man on the left of the picture is a Mr. Brown. Ferry captain Claude Beaujean stands between the two gentlemen on the right in this 1912 photo.

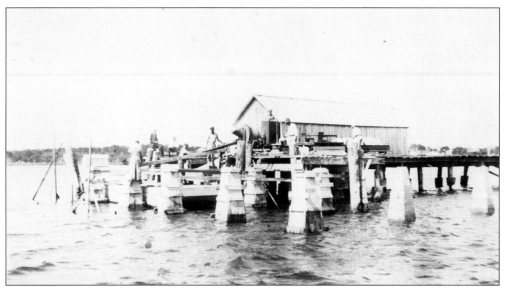

This is a view that was presented to ferry passengers in early 1918. Concrete pilings were being poured for a new pier.

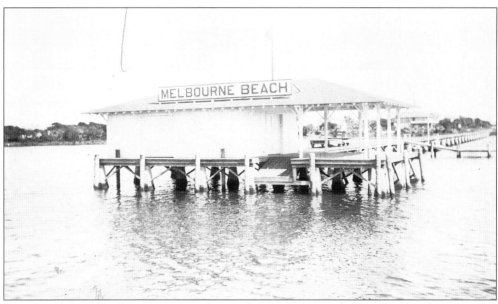

By 1918, the pier had been completely rebuilt. Wooden pilings remained until they rotted away, and the weight shifted entirely to the newly poured concrete pilings. Sand for the pilings came from the ocean beach. The ramp was used to offload freight from boats and barges.

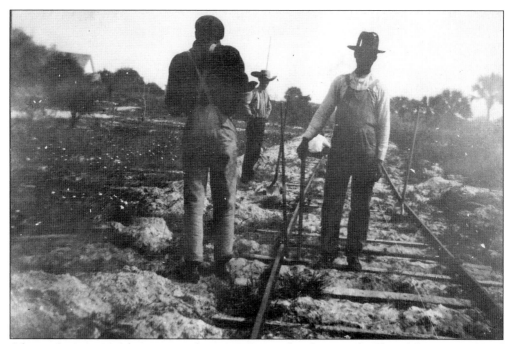

African-American workers are seen here repairing and replacing rails. These laborers were good enough to work, but white residents generally did not want them spending the night in the community. A June 2, 1925 official notice directed African-American laborers and families to swim a mile south of the nearest white beachfront residence, supposedly out of sight.

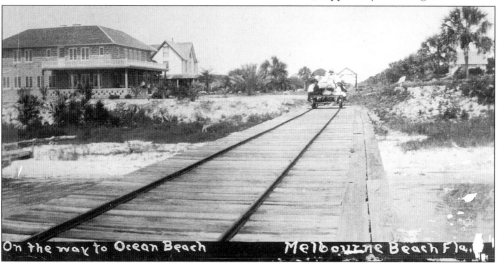

On the way to Ocean Beach Melbourne Beach Fla.

The February 28, 1889 issue of the *Florida Star* contained the following item concerning Melbourne Beach: "The Rockledge (ferry), brought down another lot of steel rails Saturday night. Captain Mercier kindly took a number of Melbournites over to the railroad dock on Sunday afternoon. A few minutes enabled the party to cross to the sea shore while the rails were being unloaded. About two-fifths of the rails are laid on the Melbourne and Atlantic railroad, not tramway. The road is of standard gauge. Captain Wilcox is pushing the road ahead as fast as the rails can be gotten on the ground." The rails had to be transported by steamboat because the railroad stopped at Titusville.

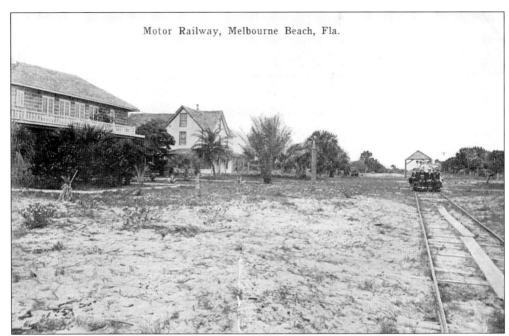

Motor Railway, Melbourne Beach, Fla.

Another item of progress is given in the March 14, 1889 *Florida Star*: "Captain Wilcox has had surveyor Burchfiel running levels for the railroad to the beach. The height of the land above the water on the riverside is eleven feet, this being one of the lowest points on that shore for some distance. From thence the land gradually ascends until, at the buff on the seaside, it is twenty-one feet above the ocean. The captain is having the land cleared as fast as possible for a large pineapple patch, and also the streets and avenues, leaving oaks, myrtles, hickories, etc. occasionally for future shade trees."

The motor car in this picture came from a company called Buba Motor Car Company. Capt. R.W. Beaujean is the driver. One of the vivid memories of old timers of the area is of the screech and noise of the tram as it advanced over the rails.

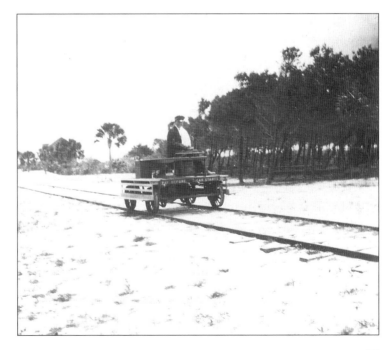

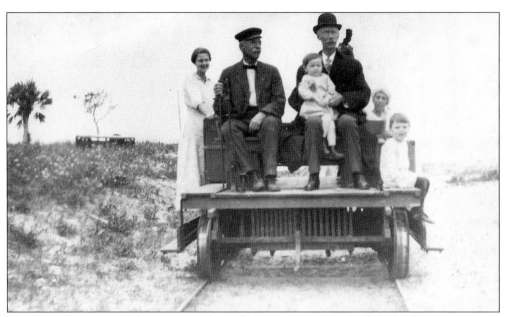

This is another image of the motor car driven by Beaujean in March of 1915. The passengers are unknown.

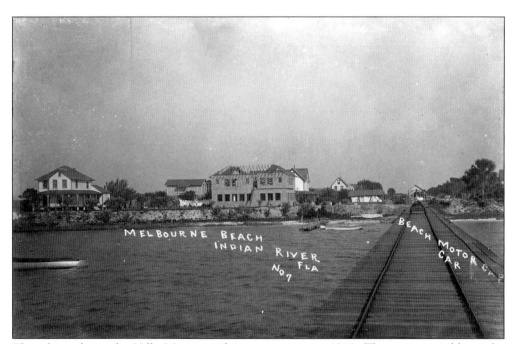

MELBOURNE BEACH
INDIAN RIVER
FLA
No 7

BEACH MOTOR CAR

This photo shows the Villa Marine under construction in 1912. The tram is visible in the distance. Today the Villa Marine is the office of dentist Byron Beard.

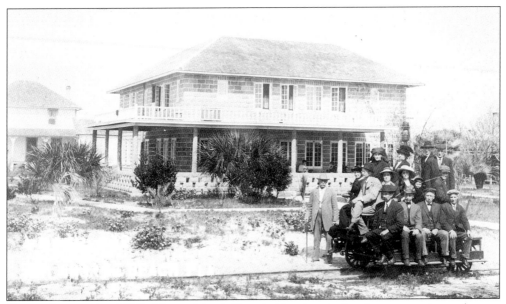

Here is the completed Villa Marine Hotel. Captain Beaujean is showing prospective real estate buyers around. The concrete blocks for this structure were made using sand from a large pit dug on the site.

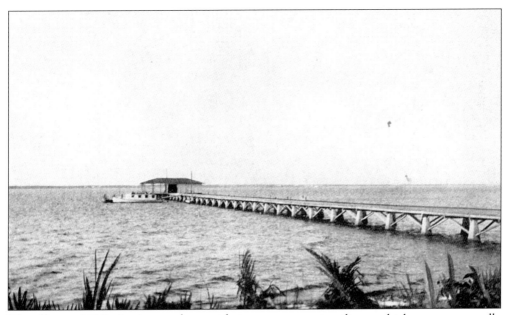

The all new 1918 pier is seen here with its new concrete pilings, which were supposedly impervious to worms and rot. However, they soon began to crumble. Perhaps too much sand, which came from the beach, was in the mixture.

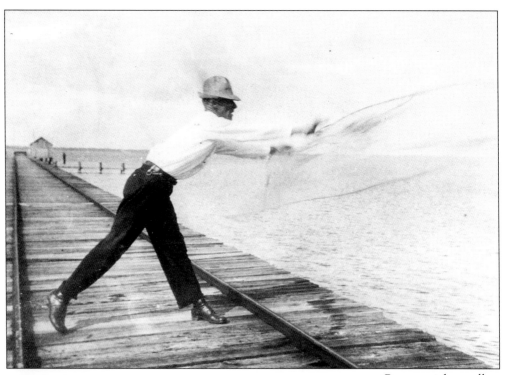

Commercial as well as amateurs cast-netted for fish. Here Don Beaujean casts. Most of the fish caught by this method were mullet.

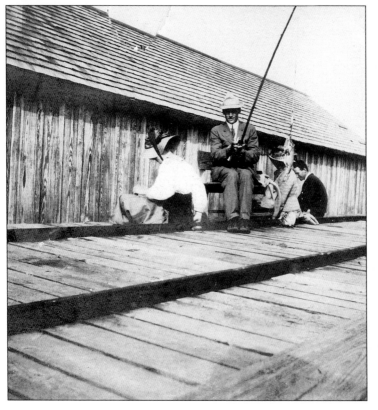

This is a c. 1912 view of the original 1889 dockhouse at the end of the pier. The original stock holders anticipated the need to store building materials here fresh off the boat, but they need not have bothered. The construction business was very slow.

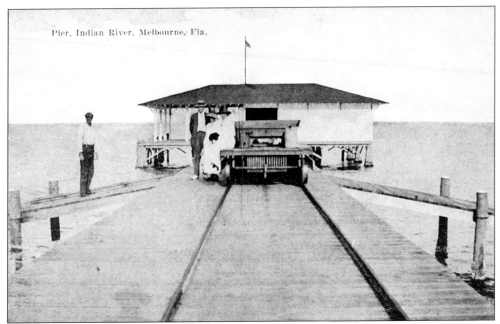

The new pier and dockhouse were completed in 1918. The enclosed dockhouse was to "protect valuable freight."

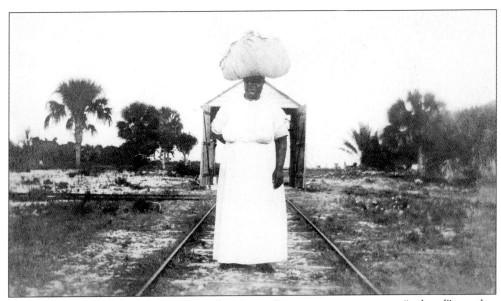

"Big Eva" was the laundry lady at the Villa Marine. Despite segregation, two "colored" couples with the last names of Avant and Hughes lived as "help" for many years on the island.

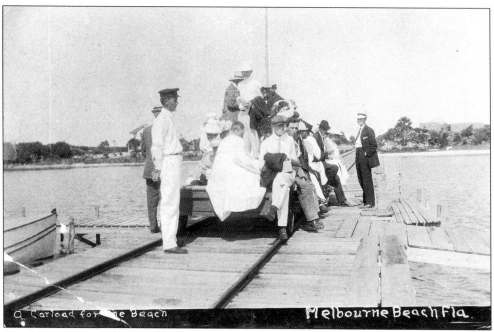

Claude Beaujean, in white, is about to carry passengers who have just come over on the ferry on a 1-mile journey to the beach. The tram had become motorized in 1909, a year before this photo was taken.

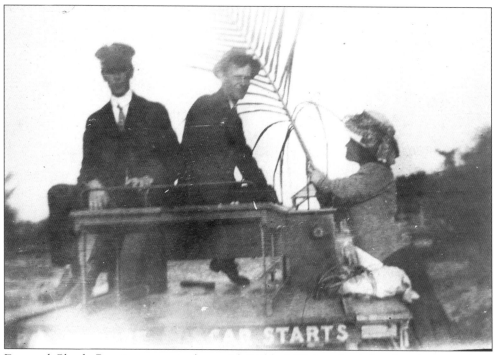

Don and Claude Beaujean are seen here with Mildred Hicks, who is fanning the mosquitoes away with a palm branch. The message on the bottom of the car states "pay before car starts."

This group does not appear to be fishermen or surf bathers. Did they simply come to enjoy the ocean breeze? Or perhaps to visit friends? Or did riding back and forth on the tram provide sufficient entertainment?

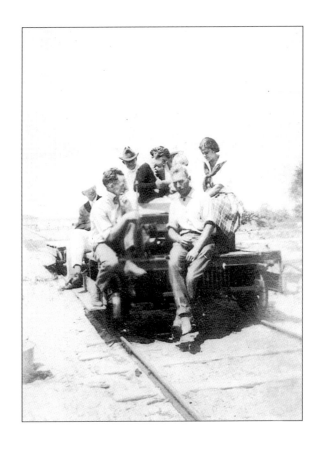

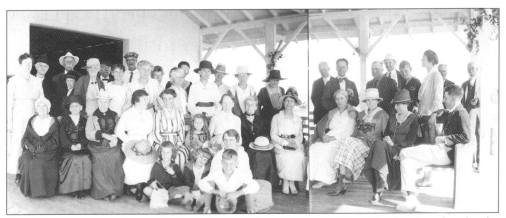

To celebrate the new dock, all 41 residents on the north part of the island gathered under the shelter at the end of the dock for a picnic as seen in this 1918 picture.

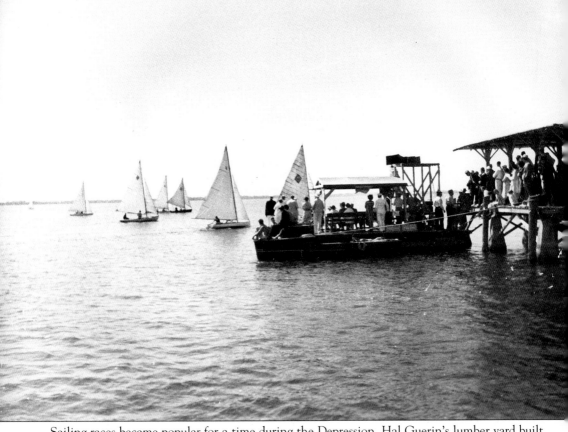

Sailing races became popular for a time during the Depression. Hal Guerin's lumber yard built many of this moth-size class. He was unsuccessful selling lumber for houses, so he built boats instead. The U.S. Moth class championship races were held in Melbourne Beach in 1936. (Courtesy of Sea Bird Publishing, Inc.)

Seven

THE OCEAN BEACH

The beach is and has been many things to people. To the native Ais Indians, the barrier island beach was a place to winter because the inlets and the ocean provided a rich food source. Migrating kingfish, bluefish, and menhaden were easily taken from the surf and from offshore sail canoes. Ambergris, a substance emitted by the sperm whale, was valuable to several corrupt Spanish governors in St. Augustine, who would trade that struggling colony's scarce manufactured goods for it. To the Spanish sailor, the ocean shore meant danger. For two centuries, Spanish treasure ships sailed northward within sight of our Melbourne Beach coast during every season of the year. For whatever reason, the Spanish never figured out that hurricane season extended from June through October. Although the best-known maritime disaster the Spanish encountered was the 1715 sinking of an entire treasure fleet, in which only 1,500 people survived, numerous other vessels wrecked along our coast. The rationale for sailing within sight of shore on their return journey to Spain was simple. They sailed this part of the voyage by dead reckoning. At the very obvious landmark of Cape Canaveral, which jutted eastward into the Atlantic, the ships turned right, or east, to find Spain straight ahead and just a bit north across the Atlantic Ocean.

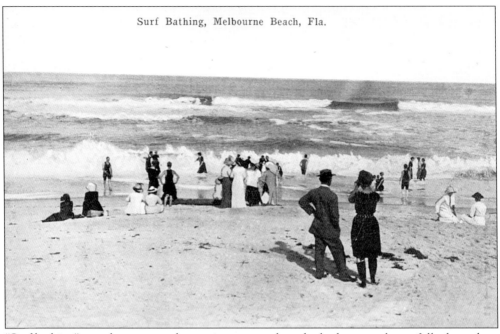

Surf Bathing, Melbourne Beach, Fla.

"Surf bathing" was always a popular pastime, even when the bather was almost fully dressed.

Observations on a
Florida Sea-Beach
with reference to
— Oil Geology —
by
J. F. Kemp. 1919

J.F. Kemp was a Columbia University geologist who spent the winters of 1915–1916 and 1916–1917 at a beachfront cottage where he wrote a 21-page monograph relating his observations. Yes, there may be oil beneath Melbourne Beach!

During the thunder storm on Saturday last a party of ladies were bathing in the ocean at Melbourne Beach, they fled to the bath house for shelter, when a lightning bolt immediately struck the house, killing Mrs. R. W. Beaujean and causing the blindness of Miss Grace Cummings and at the same time severely shocking others of the party. Mrs. Beaujean was a woman in the prime of life and loved by all who knew her. She leaves a husband and two sons to mourn her untimely end. Miss Cummings is a most estimable young lady who has lived at Melbourne Beach for a number of years, and has the sympathy of a large circle of friends and acquaintances in her affliction. Truly we know not what a day may bring forth. Life, health and our faculties are held, as it were, in the balance, apparently safe in our own keeping, in reality, beyond our preserving care.

Tragedy was no stranger to the little community. The fact that this lightning strike was news over 100 miles south shows how isolated and unpopulated the Indian River was then.

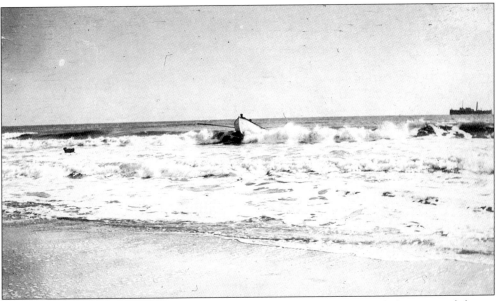

During Prohibition, rum runners from the Bahamas were known to offload choice British liquor onto shore. Boats such as this one brought the liquor through the surf, and prohibition agents were few and far between. Successful bootleggers, and especially those with a steady supply of the "safe" stuff from the Bahamas, made enormous profits.

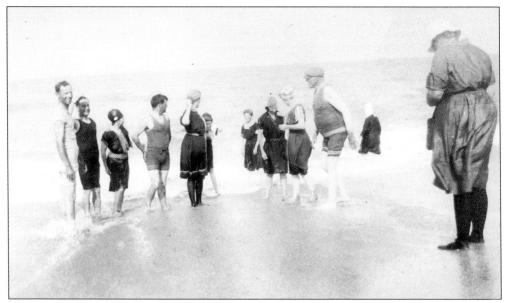

The modestly attired members of this party are having their picture snapped by the lady on the right. She is using a Kodak box camera, an inexpensive picture taker that was extremely popular.

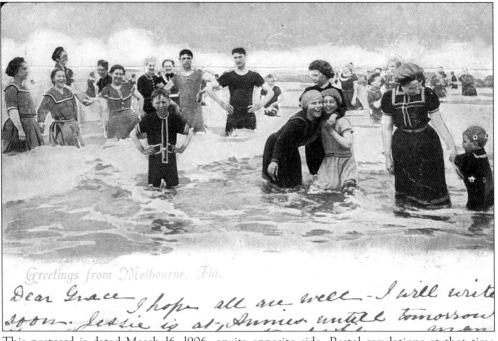

Greetings from Melbourne, Fla.

Dear Grace — I hope all are well — I will write soon. Jessie is at Annie's until tomorrow —

This postcard is dated March 16, 1906, on its opposite side. Postal regulations at that time required that one side of the card be used exclusively for the address. That is why this brief message is crammed onto the bottom of the card.

Ruth Ryckman rinses salt and sand from her friend Mildred Hicks. Ruth was a 1910 Vassar graduate and a nurse by profession. Her father was an original 1888 investor in Melbourne Beach, and, by 1908, he bought out the interest of the other investors and formed a stock company named, appropriately enough, the Melbourne Beach Company. He also bought the oldest house on the beach, the Jacob Fox house. Today, it is restored as the Ryckman House, in Ryckman Park.

Rub-a-dub dub, two in a tub, and one is supervising. These playful three are Frances Beaujean in front, and Will and Edna Sim sitting on the edge of the tub. The tub and pitcher pump were for rinsing oneself after a dip in the ocean. The car to the Melbourne and Atlantic railway is just discernible on the left background.

Grace Grossley doesn't fit into the tub very well, but by her expression she seems to be enjoying herself. This picture is *c.* 1918.

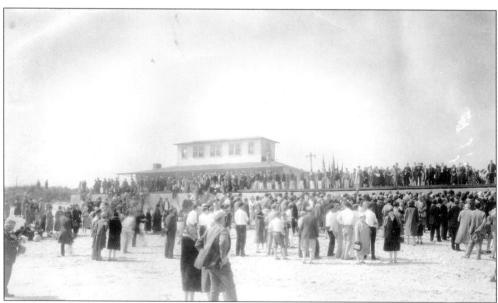

Well-known flyer Harry Brooks was killed when he crashed in the surf in 1929. He was Henry Ford's personal pilot, and it was said that Ford considered Harry Brooks almost as a son. This memorial service to Brooks attracted some 1,500 south Brevard citizens. Note that the Melbourne Beach Casino has a second story.

Here is another view of the 1929 crowd that came to the beach for Harry Brook's memorial service.

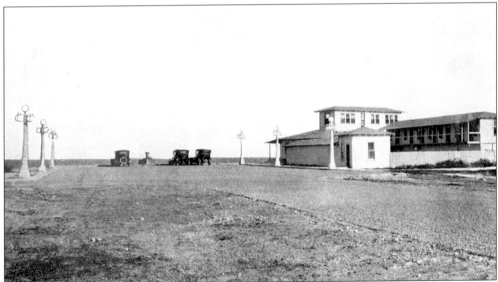

Before a strong nortleaster blew the poorly anchored second story of the Melbourne Beach Casino into the swimming pool in the early 1930s, salesmen would cajole and pontificate with prospective land purchasers from this vantage point, using their best salesmanship in trying to get customers to envision how the rattlesnake- and mosquito-infested scrub before them would, in a very short time, escalate to great value.

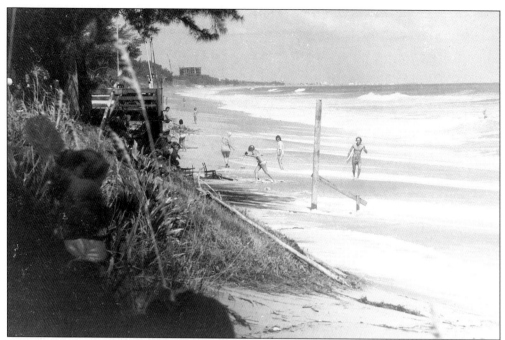

One should not forget that Melbourne Beach is a sand bar, whose natural purpose is to stop the Atlantic and beat back the thundering surf. This January 1973 photo of a northeaster indicates that a person on the beach is there at his or her own peril. (Courtesy of Sea Bird Publishing, Inc.)

A heavy surf at high tide will sweep away man-made objects that get in the way. Here, steps at Floridana Beach are being broken up by the sea.

An attempt to sandbag this ocean-front Floridana Beach property is, at best, a temporary measure. The beach is slowly being lost. This is especially true after the jetties at Port Canaveral stopped the natural southward drift of the river of sand.

This sand fence seems to have had some success in catching blowing sand, but it does not address the fundamental problem of sand in the action of waves.

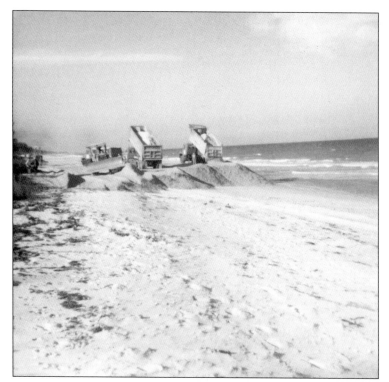

The U.S. Corp of Engineers, who created the beach erosion problem by constructing jetties 40 miles north at Port Canaveral, attempted to remedy the problem in 1981 by hauling truck loads of sand to dump on our beach. Unfortunately, the sand washed away within weeks.

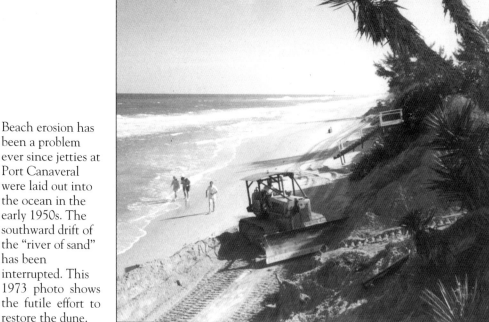

Beach erosion has been a problem ever since jetties at Port Canaveral were laid out into the ocean in the early 1950s. The southward drift of the "river of sand" has been interrupted. This 1973 photo shows the futile effort to restore the dune.

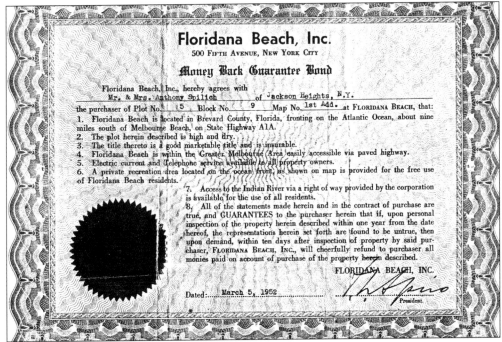

Florida real estate has never lacked a market. In 1952, Frank Spiro and Salvador De Lucian, the developers of Floridana Beach and Melbourne Shores, made their pitches to harried travelers in New York's Grand Central Station. One of the key elements in selling Florida real estate to northerners was seizing the right psychological moment in the dead of winter when the slush and mud and cold and darkness led to dreams of a sunnier clime.

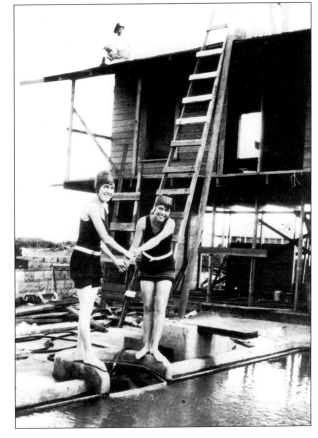

These two young ladies pose straddling the artesian water source for the new Melbourne Beach Casino Pool. Dot Bruce is on the right. This c. 1923 view is looking southeast.

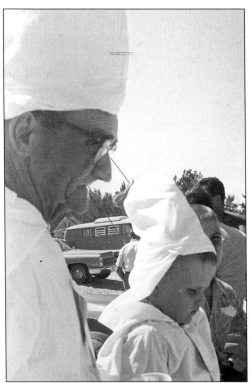

The ugliest incident to take place on our beach occurred one Sunday afternoon in August 1969, when members of the Ku Klux Klan from the central part of the state showed up. They came to express support for a local lawman who had told an interracial student group from Melbourne High School that they were breaking "an unwritten law" by being together. The Klan was no stranger to the area, however. During the 1920s, KKK activities were listed on the social page of the local newspaper. There were Junior Klans and a Woman's Auxiliary. (Photo by Julian Leek.)

The Klan's appearance would have been of little significance had not a large contingent from South Melbourne's black community showed up at the same time. By some miracle, the police managed to keep the two parties separated. After some verbal jousting, the parties left separately, much to the relief of onlookers. (Photo by Julian Leek.)

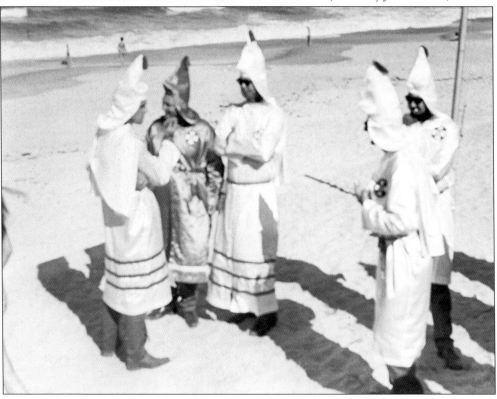

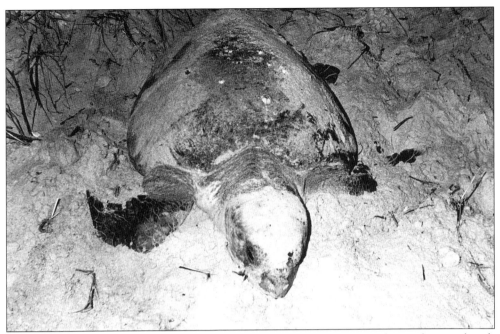

From May through September every year a natural phenomenon occurs that night-time beach walkers are privileged to observe. For ages, these sea creatures have left their natural ocean environment to laboriously inch their way up the beach to dig a nest for their eggs. (Photo by Julian Leek.)

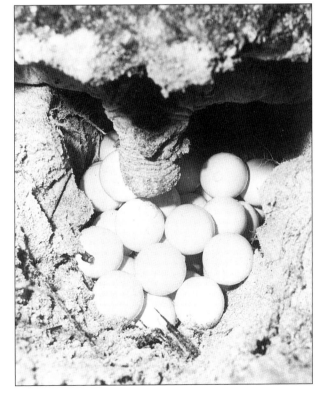

Digging the nest requires about an hour. The turtle then positions herself and for the next half hour lays from 80 to 100 Ping-Pong-size eggs. If all goes well, the turtles will hatch within 60 to 90 days. Unless disoriented by shore lights the tiny turtles run the gauntlet of shore birds to the sea, where hungry predators wait in the surf. If very lucky, the new hatchling will attach itself to a piece of flotsam and unobserved, make its way out to the Sargasso Sea. It is estimated that only one in a hundred turtles makes its way through the first year of life. (Photo by Julian Leek.)

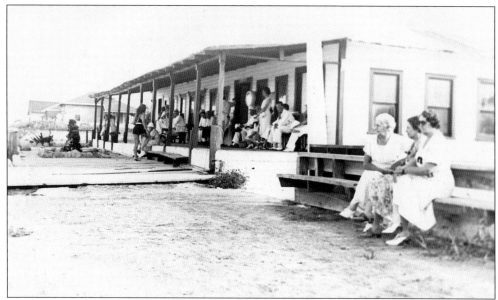

This 1935 photo captures the rusticity of ocean-front businesses long before customers demanded air conditioning. People's beach dress was decidedly different back then. (Courtesy of Sea Bird Publishing, Inc.)

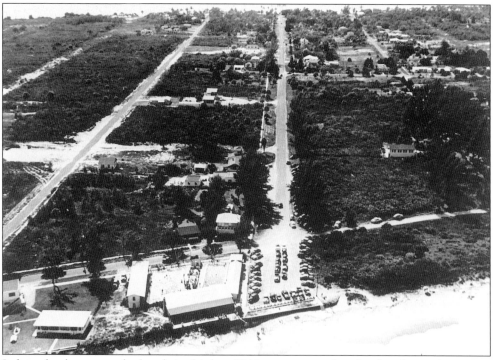

Judging by the cars at the beach in this late 1940s view across the island at Ocean Avenue, it must be a Sunday afternoon.

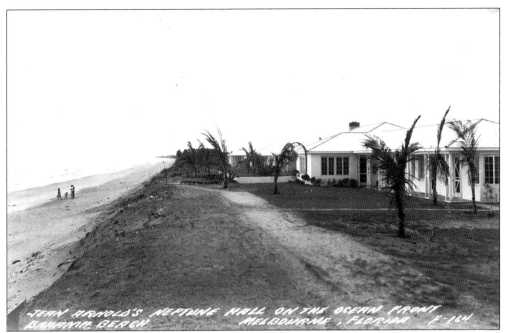

The beach was so sparsely populated for so many years that recollections of old-timers always include the "lonesomeness" and, in some cases during WW II, the fear of living with the nightly black outs. Note that this business, Neptune Hall, prefers to be located in "Bahama Beach" instead of Indialantic.

For a short time during the Depression the state legislature allowed slot machines. Here, Rene Huke is trying her luck in the casino.

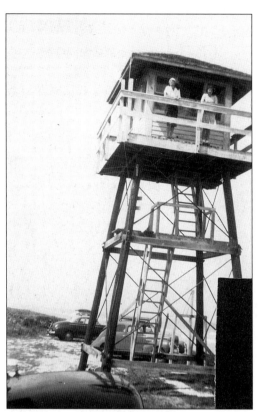

At the beginning of WW II, these coastal watch towers were erected every few miles on our coast. They were manned by the navy and were used to watch for submarine and aircraft. Triangulation was used to plot the position of aircraft that came within range of the towers, the Melbourne Naval Air Station, and the Banana River Naval Air Station. The military was housed in the barracks-type structure shown here. Today it is the Sebastian Beach Inn.

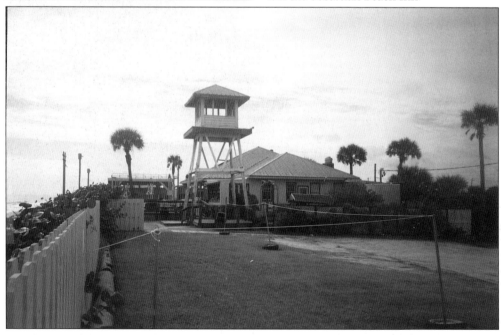

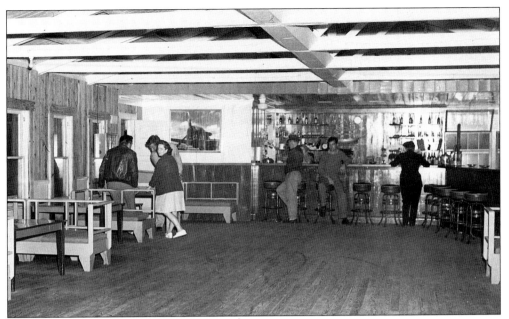

The Melbourne Beach Casino was the petty officers club of the Melbourne Naval Air Station during WW II. This rare photo of the inside of this establishment was taken in late 1945 after Butch and Alma Osborn and another partner took it over.

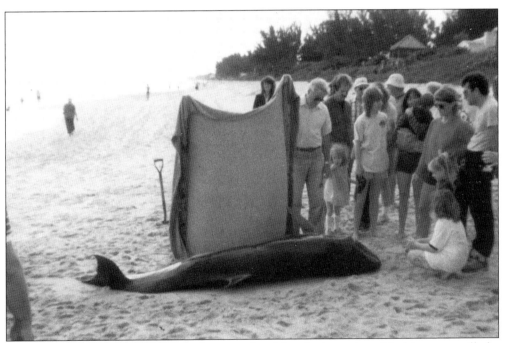

Pygmy whales occasionally become disoriented and beach themselves. Nothing can really be done, for the rescued whale will simply swim back and beach itself again. Here, well-meaning onlookers in this 1983 scene are trying to shade the animal.

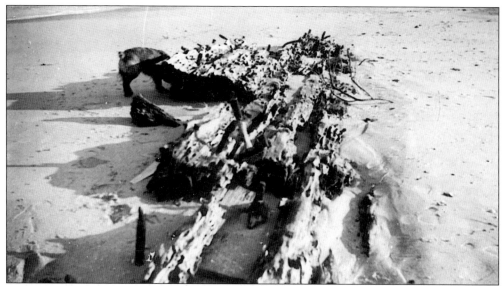

Shipwrecks have been a fact of life off Melbourne Beach ever since Spain began sending her treasure fleets along its coast. More recently, WW II saw German submarines sink half a dozen freighters and tankers within sight of the coast, and the sparsely populated beachfront remained blacked out for the duration of the war. The rationale behind constructing roads along the river at this time lay in the need to keep night car lights from being seen by the enemy submarines out at sea.

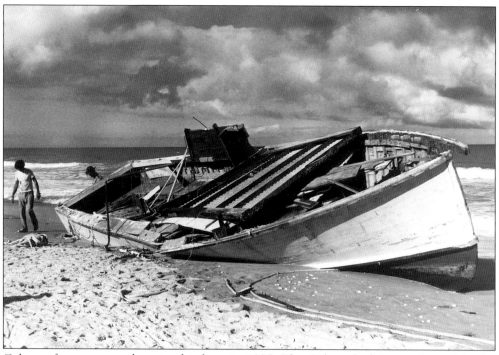

Cuban refugees came ashore in this boat in 1975. The Cubans had "stopped over" in the Bahamas and then made their way to our shore. (Photo by Julian Leek.)

This washed-up homemade raft, pictured in 1994, is the result of yet another wave of refugees leaving Cuba. One assumes the Cubans from this vessel were picked up by U.S. Coast Guard ships and the rafts left to wind and current.

Jim Lawrence stands in the middle of the only road to Sebastian Inlet in this 1926 photo.

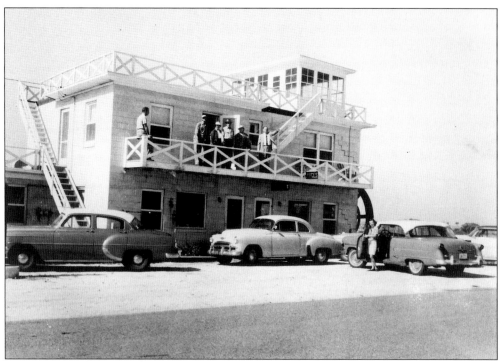

The retreat that Boyd Richards built shortly after WW II became a local landmark known as "The Old Mill." Richards is the man wearing the tie among the men on the balcony. The large water wheel ran continuously and was powered by an artesian sulfur well. "The Old Mill" had a bar and grill, gas pumps, and grocery store. The roads were so few that Eleanor Dillon said she sold real estate by canoe. But lack of access did not stop Richards, his brother Alva, and Clarance Nelson from buying up extensive acreage by paying back taxes on the property.

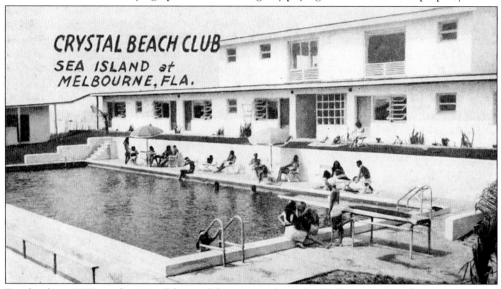

By the late 1950s, John Tos felt confident enough to build the motel and restaurant that became the Sea Dunes and is today Loggerheads. Note the open jalosie windows. These were the days before air conditioning became universally expected.

Eight

CHURCHES

Early settlers were religious. At camp meetings families would come and spend several days. The July 19, 1889 issue of the *Florida Star* gives an account of a "very pleasant outing" in Melbourne Beach, whose purpose was to organize the Indian River Sabbath School Association as a branch of the American Sunday School Union. The account states that over 400 attended, many arriving on a special excursion of the steamboat *St. Lucie*, stepping off onto the brand new pier.

Dr. W.L. Hughlett of Rockledge was the chief promoter. The meeting, which included "a most enjoyable picnic," was held on the ocean front, where "surf bathing" was also enjoyed. Officers of the new Indian River Sabbath School Association were from City Point, Rockledge, Titusville, LaGrange, Malabar, Melbourne, and Sebastian.

Three years after this Sabbath School gathering, 1892, the non-denominational Community Chapel was built. In mid-twentieth century it was still the only church on the barrier island. But after this date, an expanding post-war and Space Boom economy brought an enormous growth in population, and with this growth came the need for churches. Five Christian denominations: Baptist, Lutheran, Presbyterian, Episcopal, and Catholic have acquired land within the past few decades and built structures that have had to be greatly expanded as congregations have grown. In several cases the original sanctuary is now the fellowship hall.

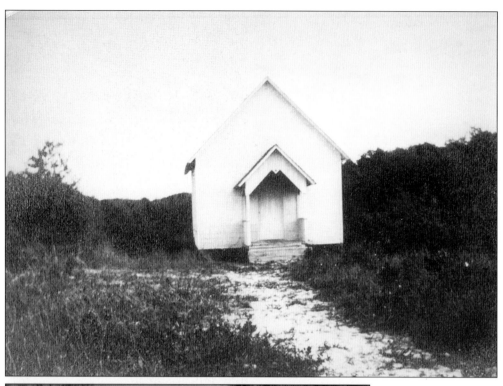

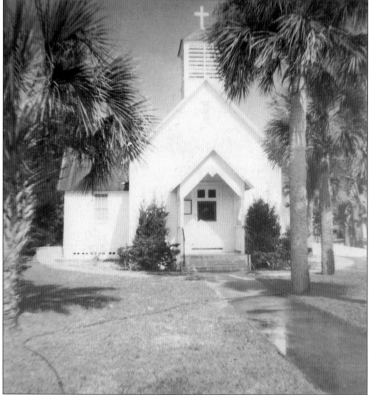

The earliest church on the island was the Community, or Union Chapel. In donating the land, Henry Whiting stipulated that the chapel was to be forever non-denominational. The chapel was built in 1892 at the cost of $200, and R.W. Beaujean was the builder. Over the years, additions, including a transept (so that the enlarged structure forms a Latin cross) and a bell tower, have been added. The chapel has attained the distinction of being on the National Register of Historic Places.

The original Eastminster Presbyterian Church was built in 1950. The congregation continues to thrive.

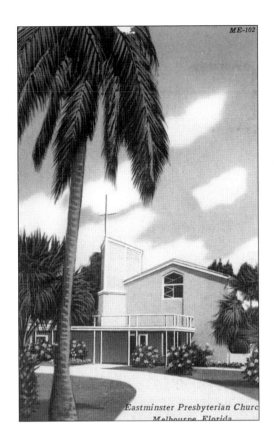

Grace Lutheran Church is on south Oak Street. The fact that two new Melbourne Beach churches were built during the same year, 1965, bears witness to a rapidly growing population brought about by the Space Boom economy (see next picture).

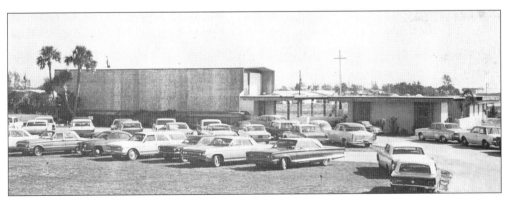

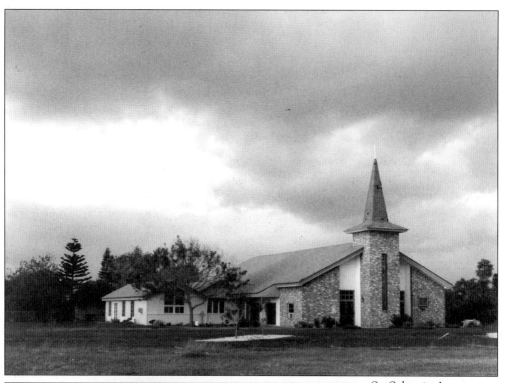

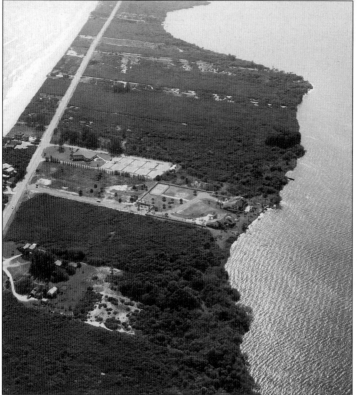

St. Sebastian's Episcopal Church was also built on south Oak Street in 1965. It has an active congregation.

This view of Immaculate Conception Catholic Church shows that section of the island as it appeared in the early 1980s. The church was built in 1980 and continues to thrive.

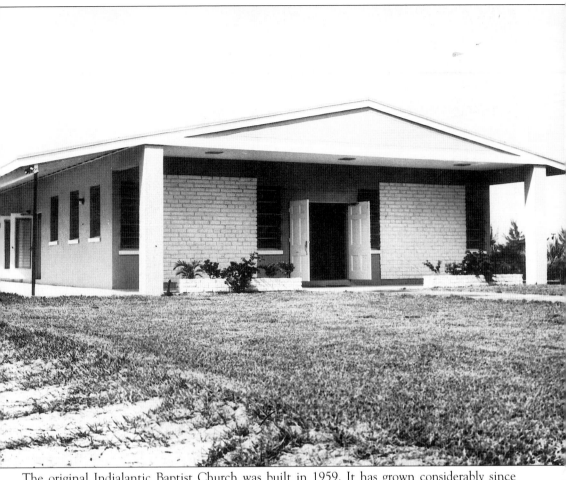

The original Indialantic Baptist Church was built in 1959. It has grown considerably since then. This church is the northernmost church within the scope of this history.

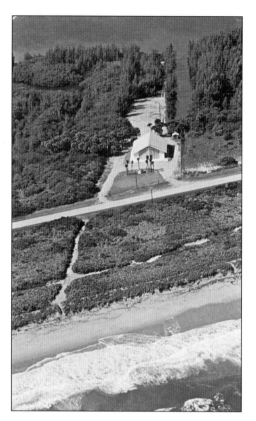

The Chapel by the Sea, Reformed Presbyterian, built in 1974, has the distinction of having had in its membership one of the brightest lights ever to live on the south beach, the indomitable Julia Lake Kellesberger. Dr. Eugene Kellesberger and his wife were medical missionaries in deepest Africa before deciding to seek a Florida home for their approaching retirement. They bought several lots that famed religious musician Homer Rodeheaver was trying to sell in his "Christian Colony." The trials and all-too-real tribulations in their "middle of nowhere" new home are delightfully recounted in Mrs. Kellesberger's memoir, *Rooted in Florida Soil*.

Rodeheaver Buys Tract Near Inlet

3/2/45

Famous Religious Singer Acquires 1,000 Feet Of The Old Ballard Grove

To Rebuild Old House And Improve Property

Rodeheaver Land Extends From Atlantic Ocean To The Indian River

A CHRISTIAN COLONY IN SUNNY FLORIDA ON THE ATLANTIC OCEAN